ART NOUVEAU

An Anthology of

Design and Illustration

from The Studio

Selected by

Edmund V. Gillon Jr

DOVER PUBLICATIONS, INC.

NEW YORK

Art Nouveau: An Anthology of Design and Illustration from "The Studio" is an original collection of pictures and is first published by Dover Publications, Inc., in 1969. The specific source and the identification of the artist for each picture is given in the list at the end of this volume.

This volume belongs to the Dover Pictorial Archive Series. Up to ten illustrations from this book may be reproduced on any one project or in any single publication, free and without special permission. Wherever possible include a credit line indicating the title of this book, editor, and publisher. Please address the publisher for permission to make more extensive use of illustrations in this book than that authorized above.

The republication of this book in whole is prohibited.

Standard Book Number: 486–22388–4
Library of Congress Catalog Card Number: 73–82624

Manufactured in the United States of America
Dover Publications, Inc.
180 Varick Street
New York, N.Y. 10014

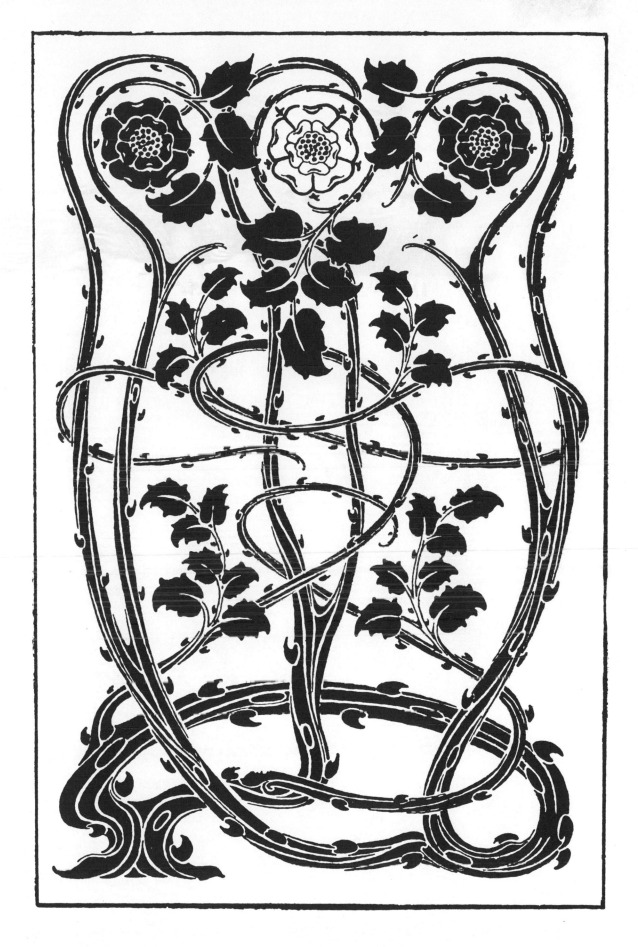

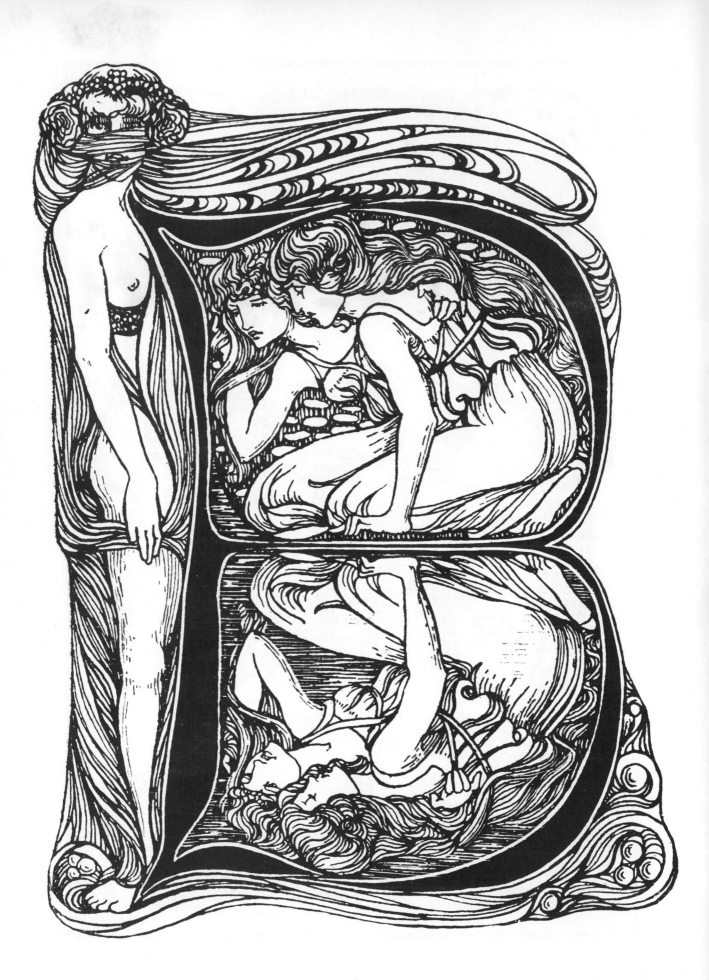

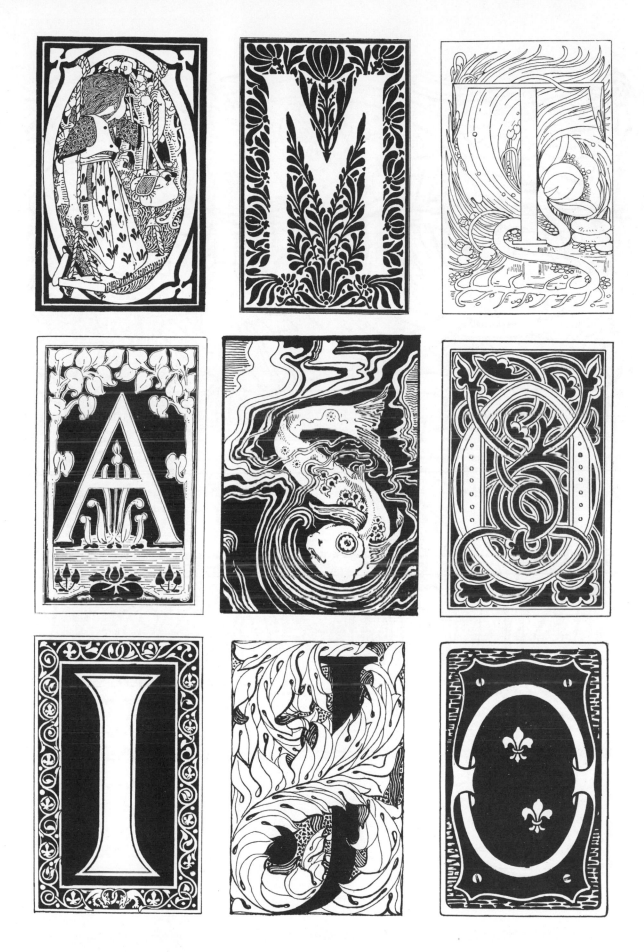

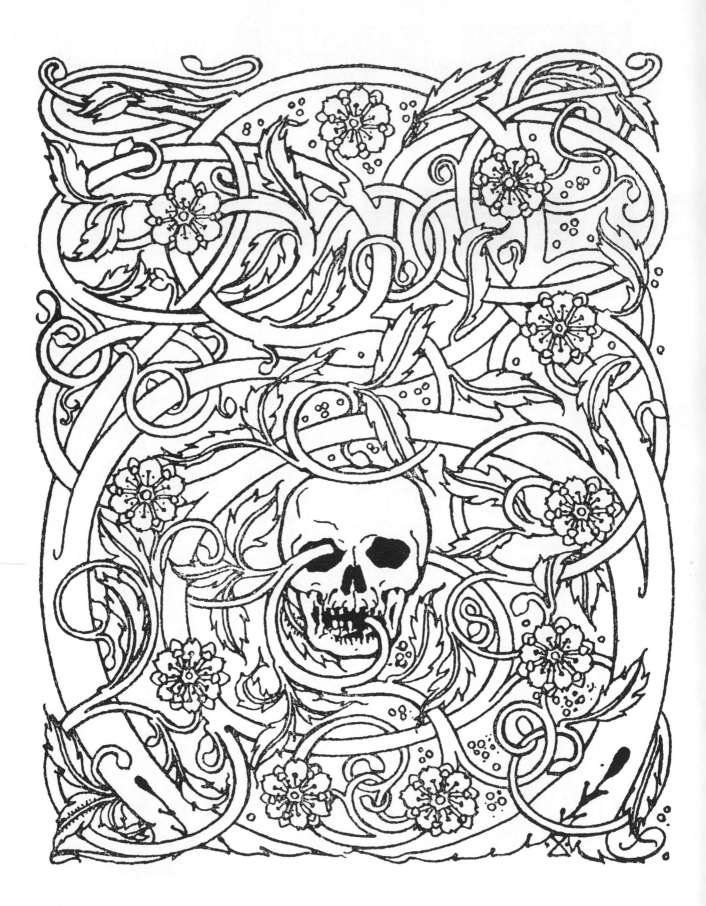

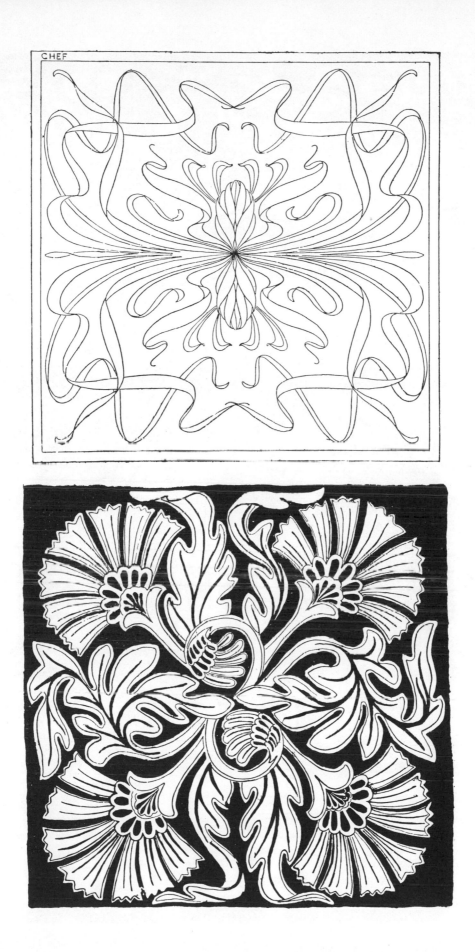

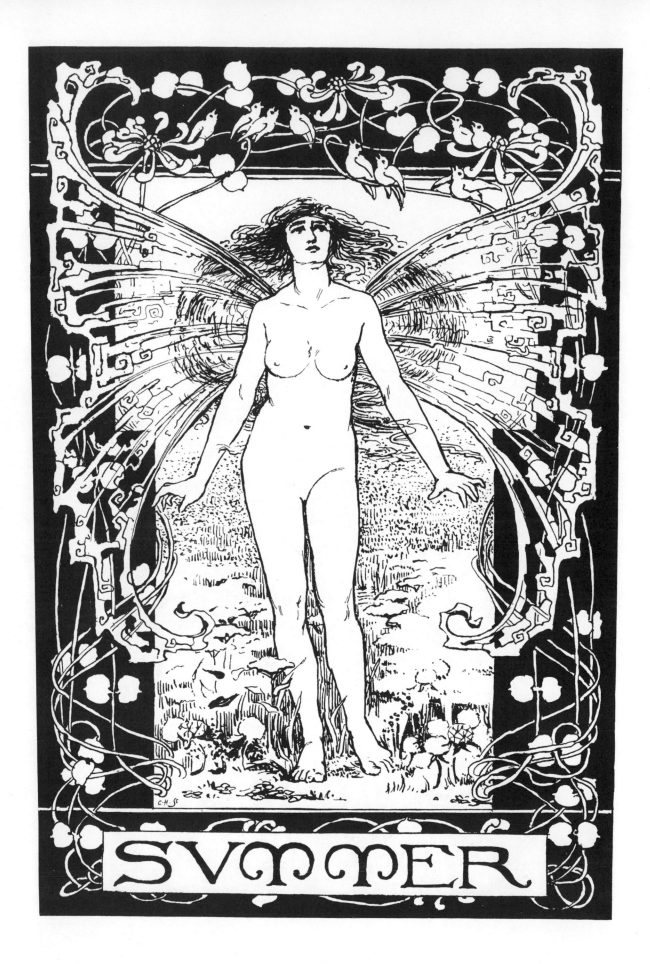

SVMMER

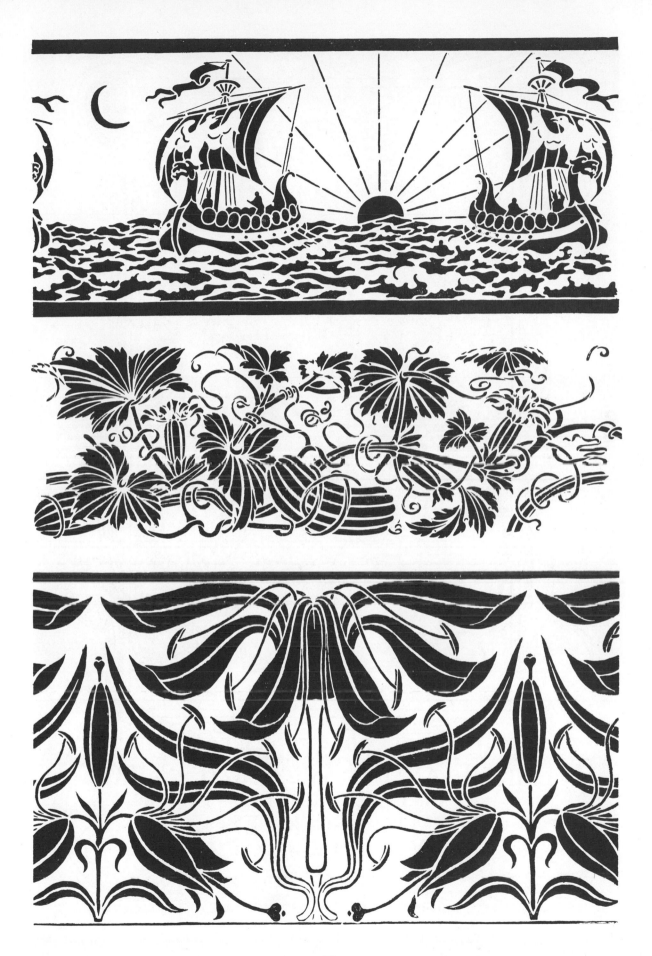

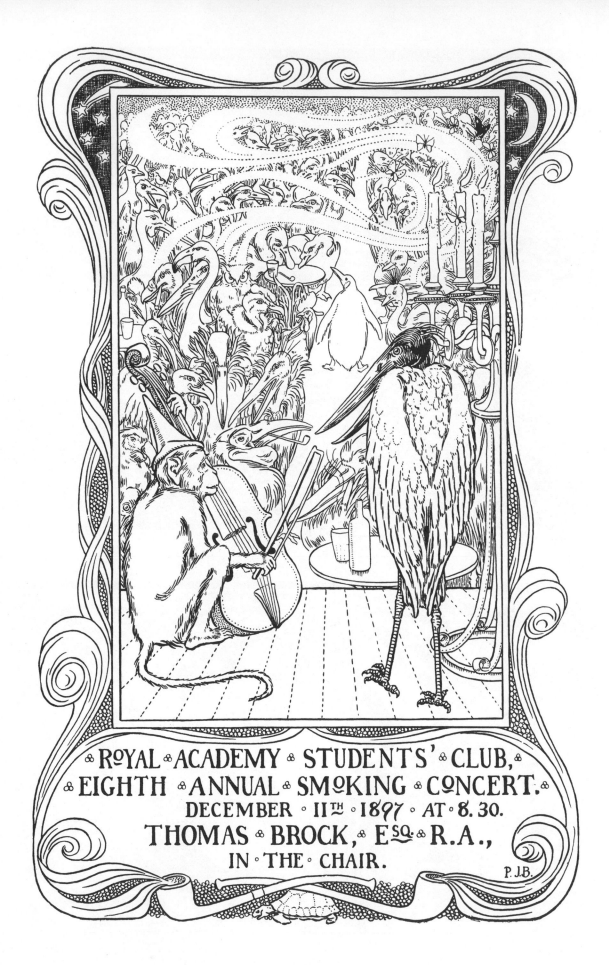

ROYAL ACADEMY STUDENTS' CLUB,
EIGHTH ANNUAL SMOKING CONCERT.
DECEMBER · 11ᵀᴴ · 1897 · AT · 8. 30.
THOMAS BROCK, Eˢ۹ R.A.,
IN · THE · CHAIR.

P.J.B.

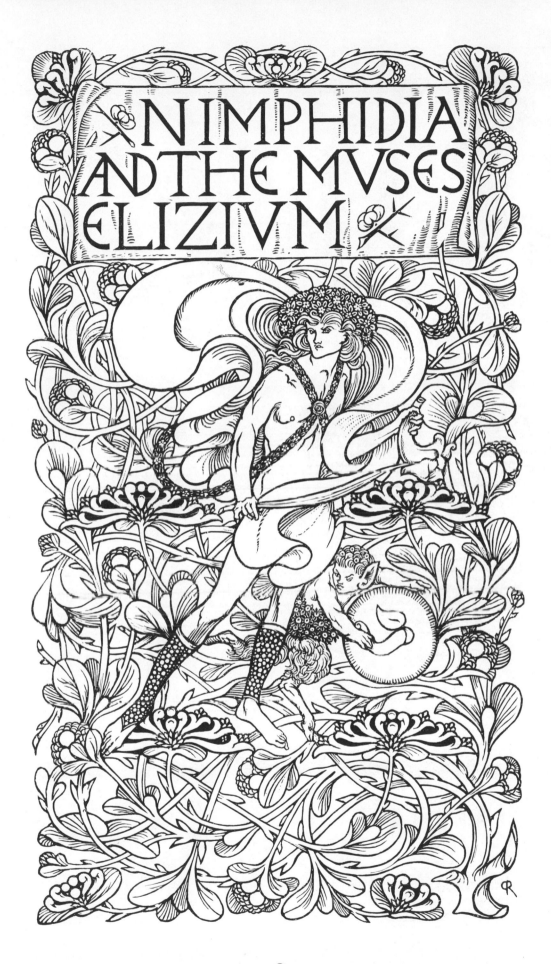

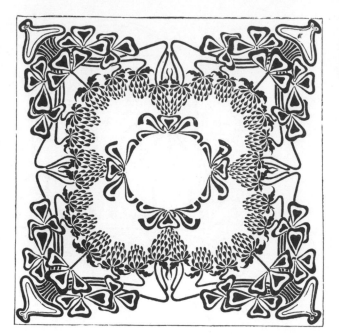

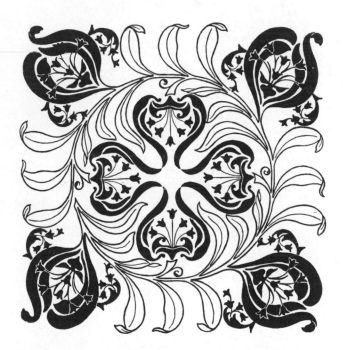

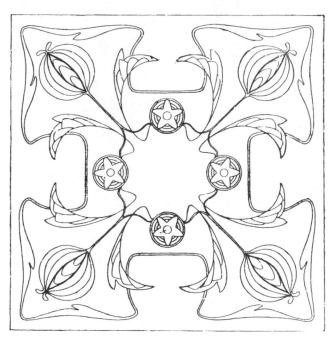

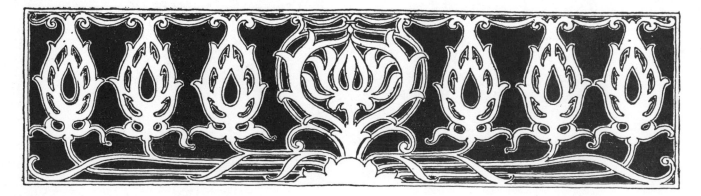

The Poams
-OF-

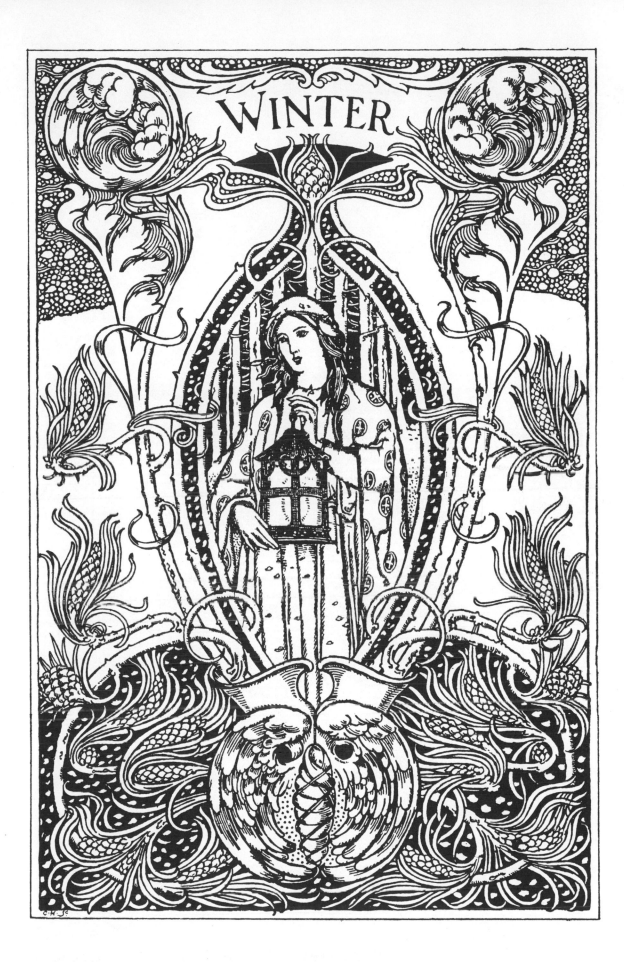

WINTER

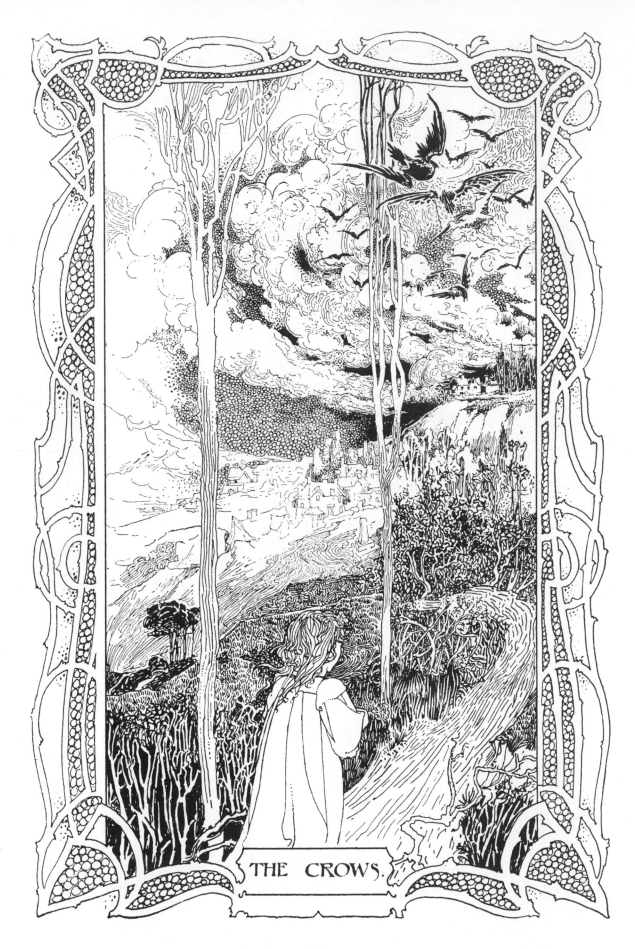

THE CROWS.

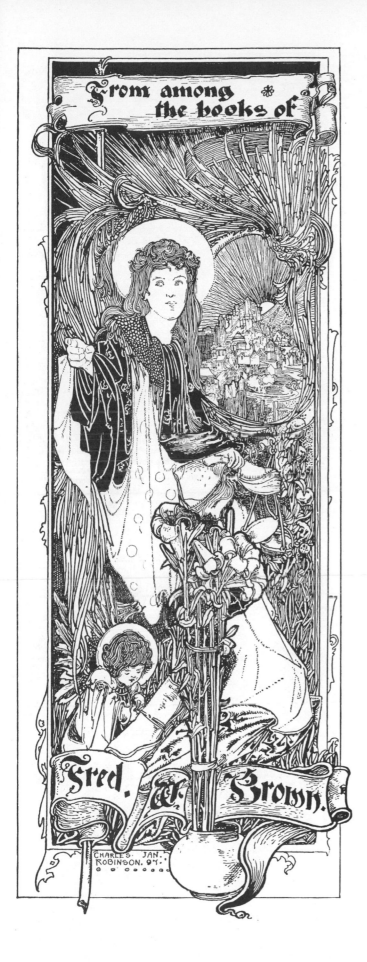

From among
the books of

Fred. W. Brown.

CHARLES JAN.
ROBINSON. 94.

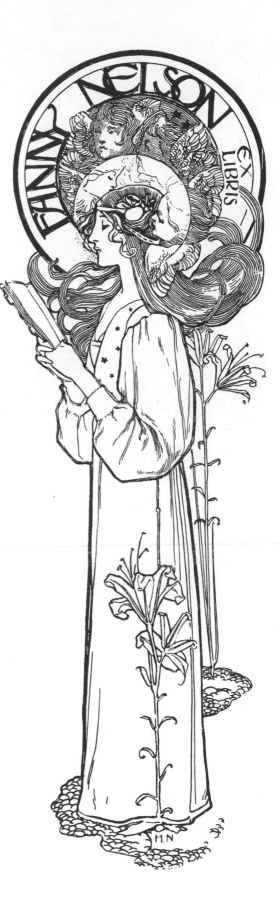

FANNY NELSON

EX LIBRIS

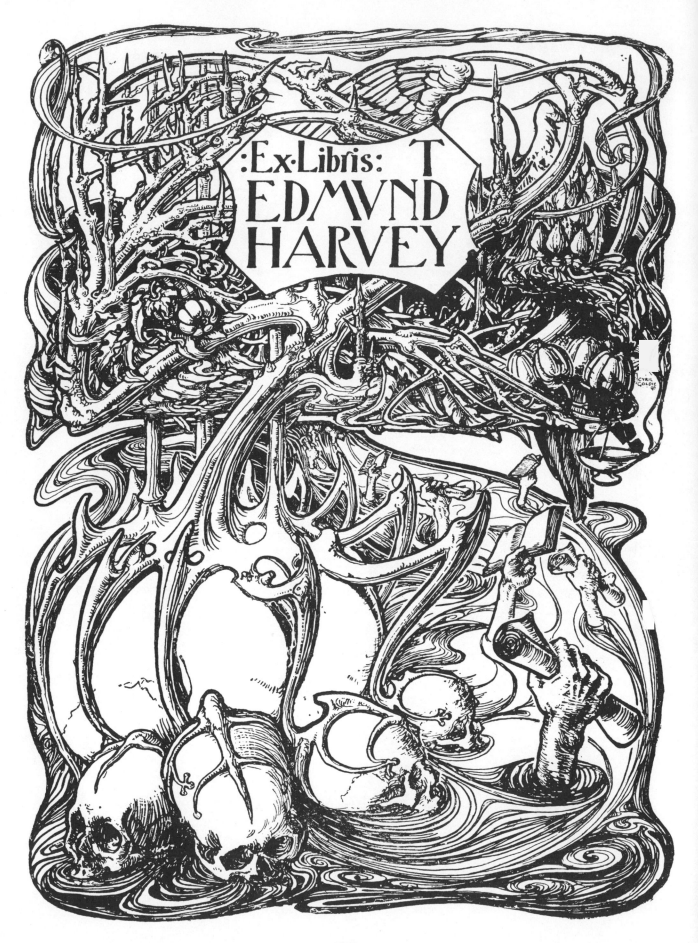

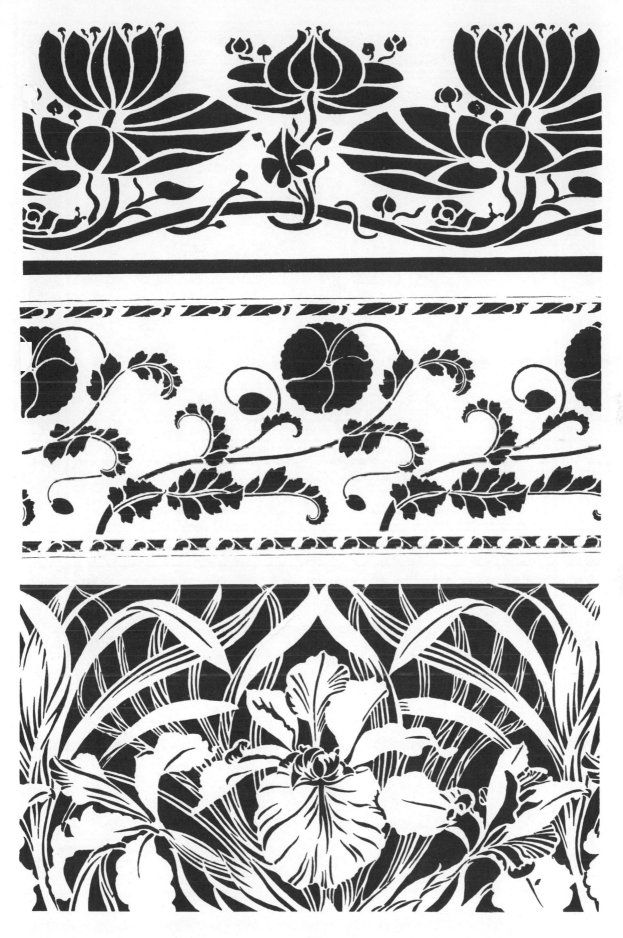

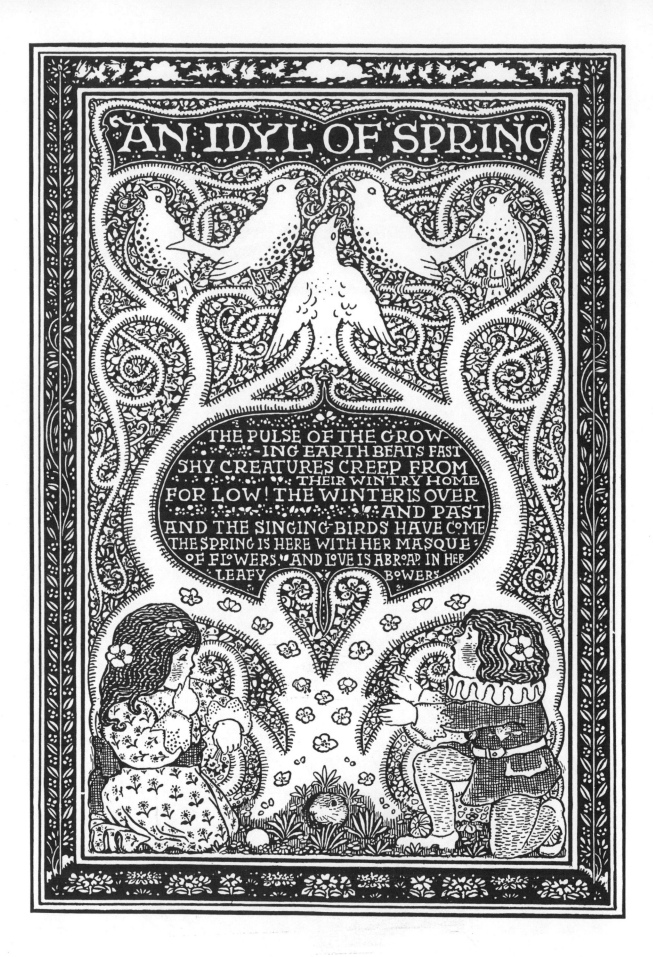

AN IDYL OF SPRING

THE PULSE OF THE GROW-
-ING EARTH BEATS FAST
SHY CREATURES CREEP FROM
THEIR WINTRY HOME
FOR LOW! THE WINTER IS OVER
AND PAST
AND THE SINGING-BIRDS HAVE COME
THE SPRING IS HERE WITH HER MASQUE
OF FLOWERS. AND LOVE IS ABROAD IN HER
LEAFY BOWERS

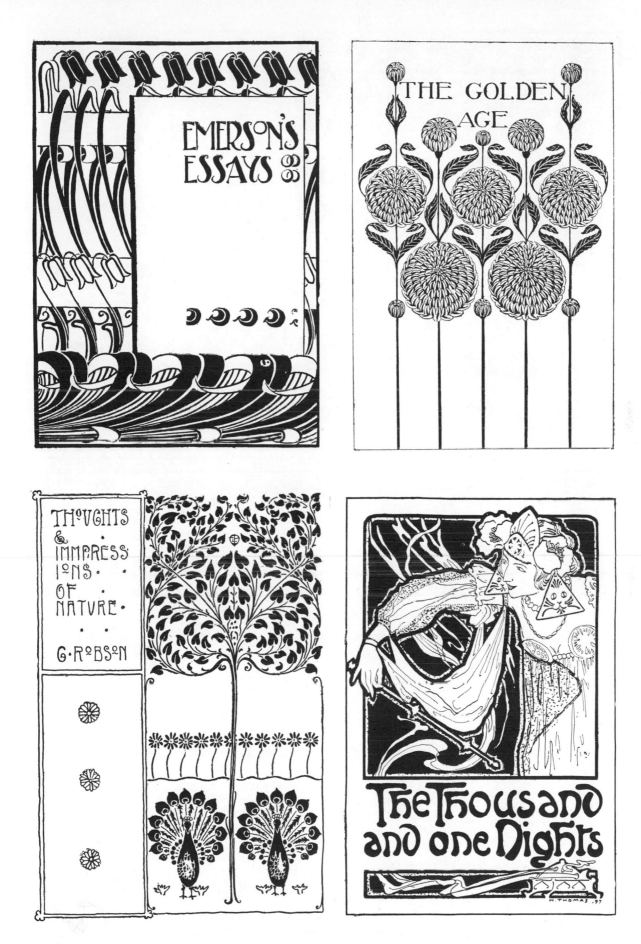

THE · ANNALS
OF · THE · PAR-
ISH · AND · THE
AYRSHIRE
LEGATEES

ILLUSTRATED
BY
CHARLES · E · BROCK

EX·LIBRIS

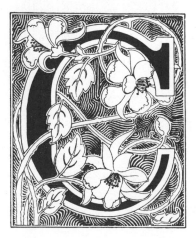
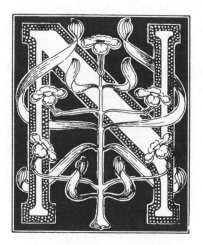

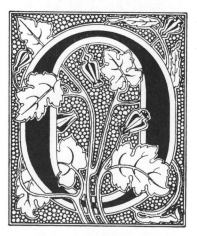
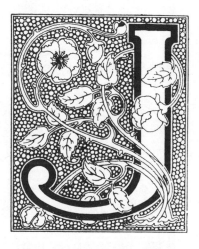

RALPH H. BAYLEY

EX LIBRIS

23

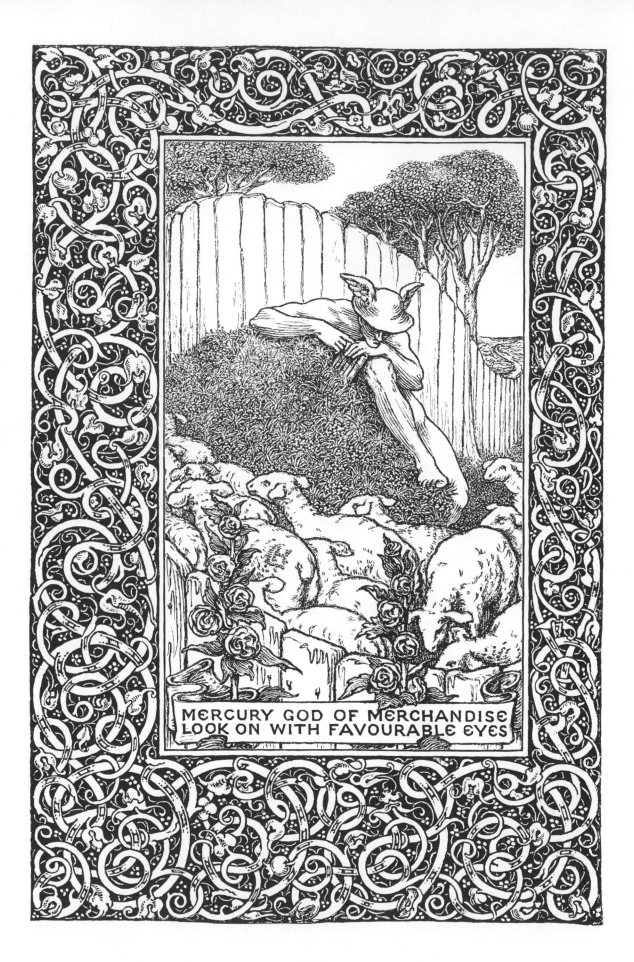

MERCURY GOD OF MERCHANDISE
LOOK ON WITH FAVOURABLE EYES

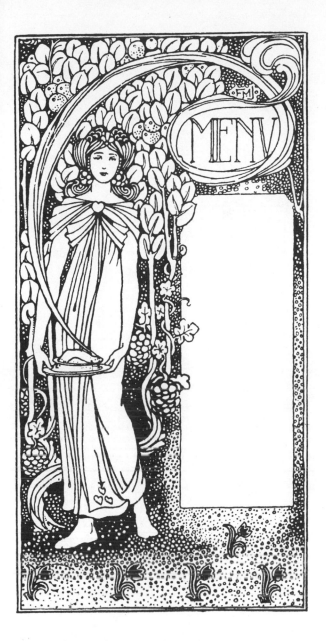

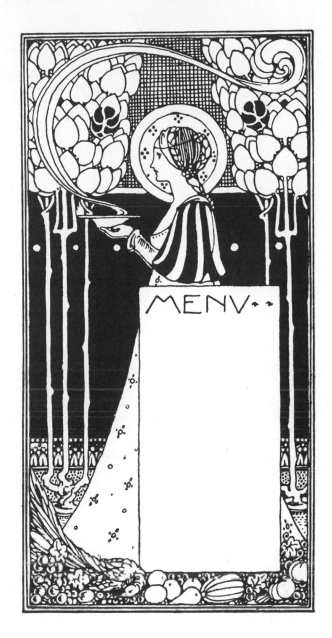

25

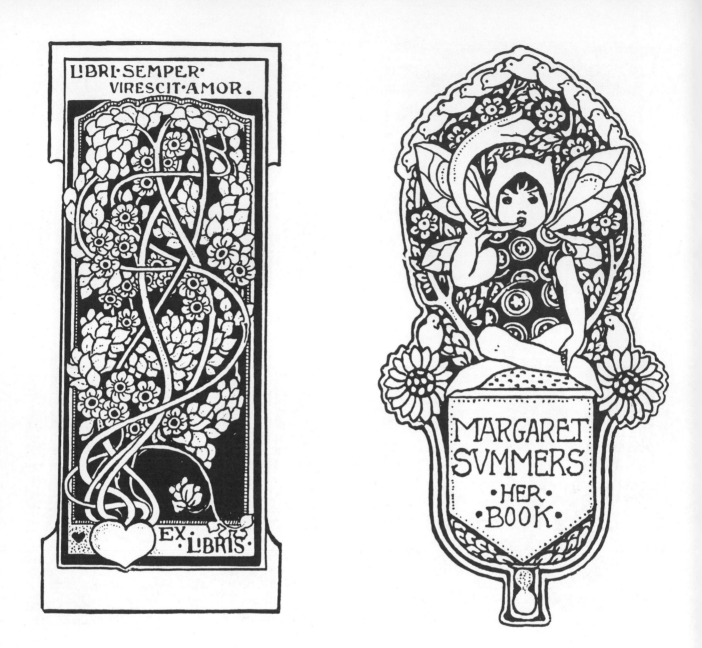

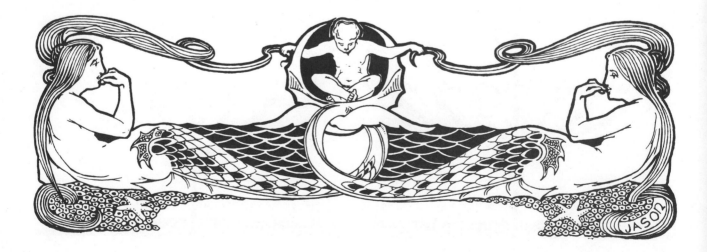

26

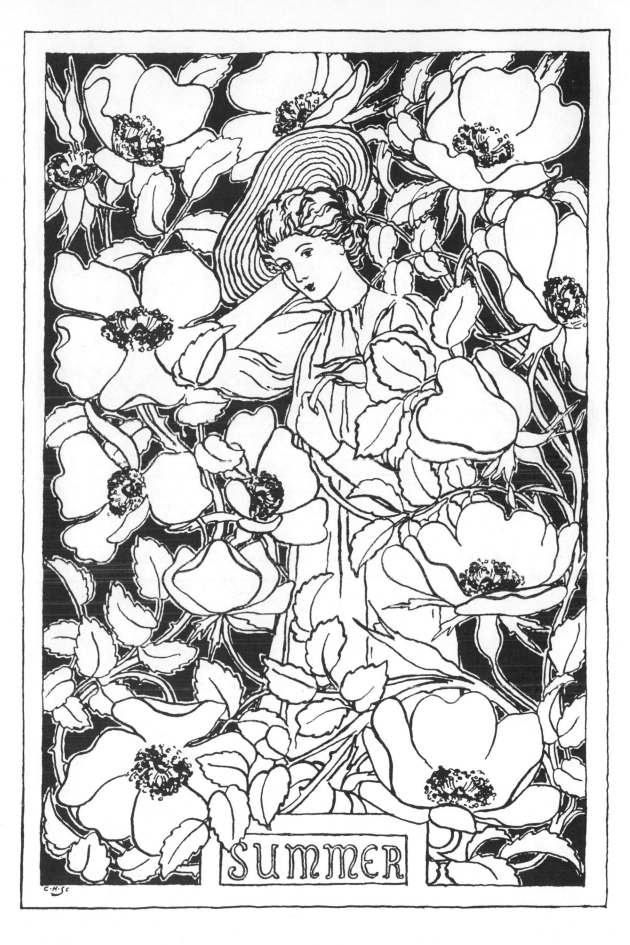

SUMMER

FORD MADOX BROWN A RECORD OF HIS LIFE AND WORKS

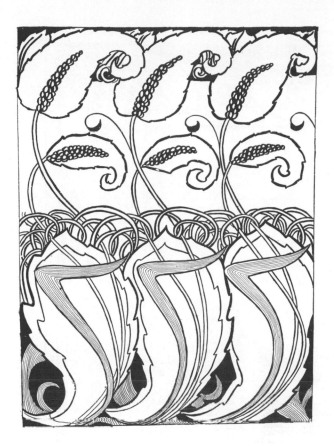

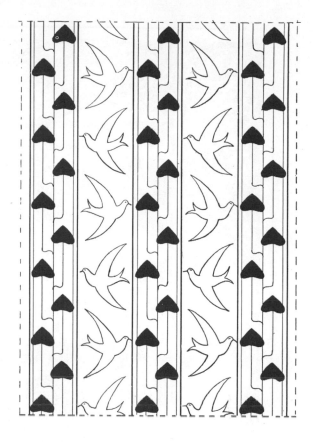

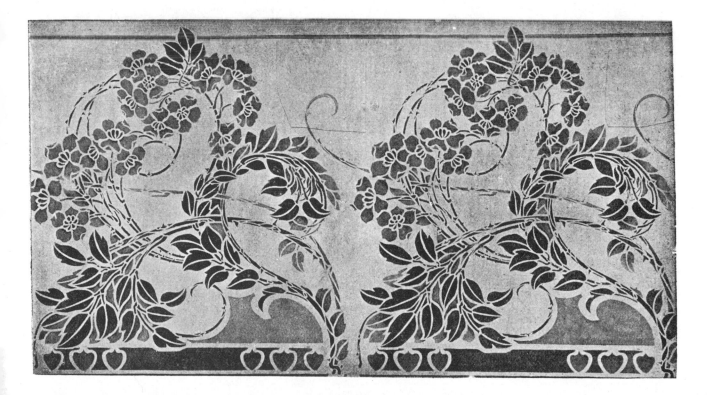

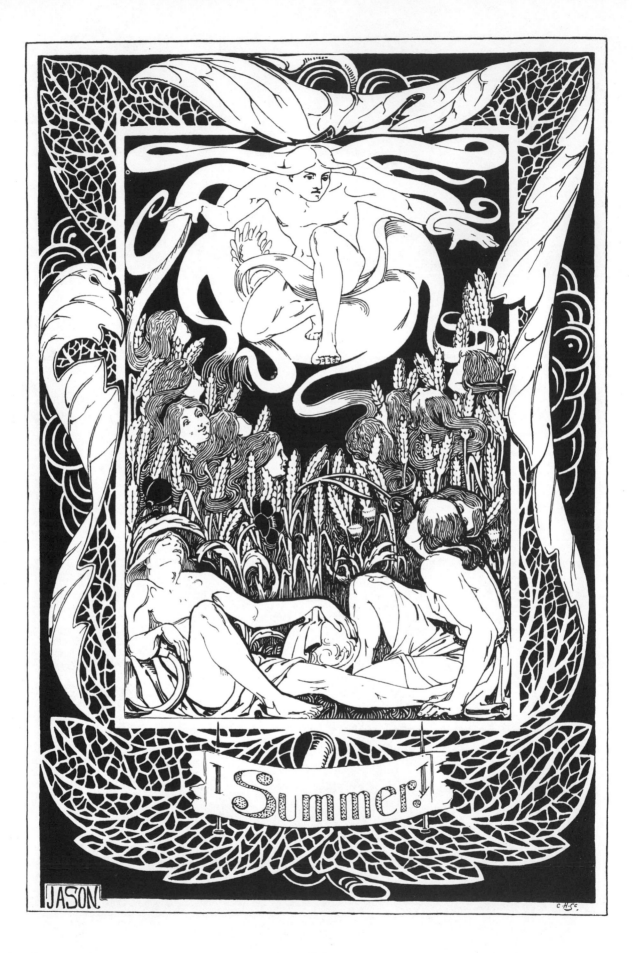

JASON

Summer

C·H·5·

30

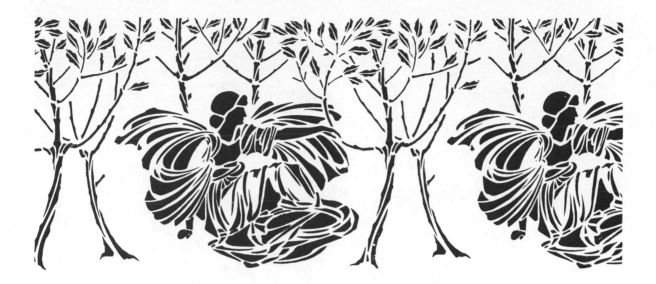

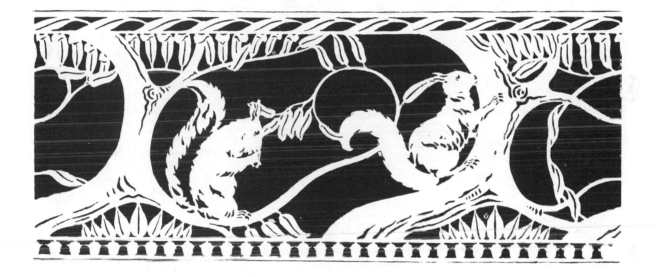

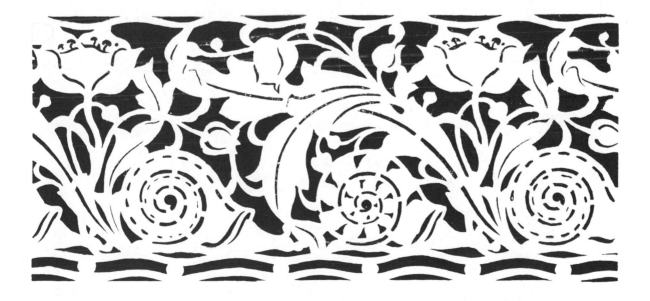

31

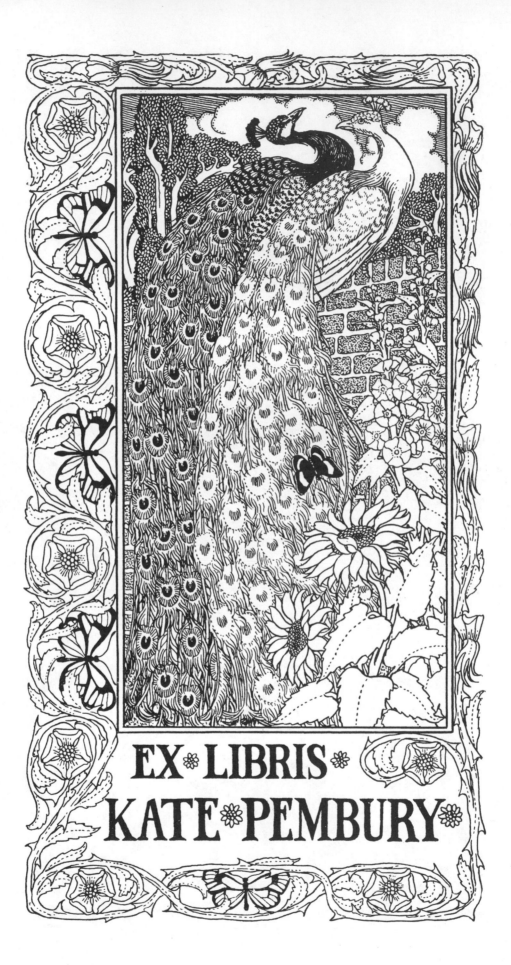

EX·LIBRIS·
KATE·PEMBURY

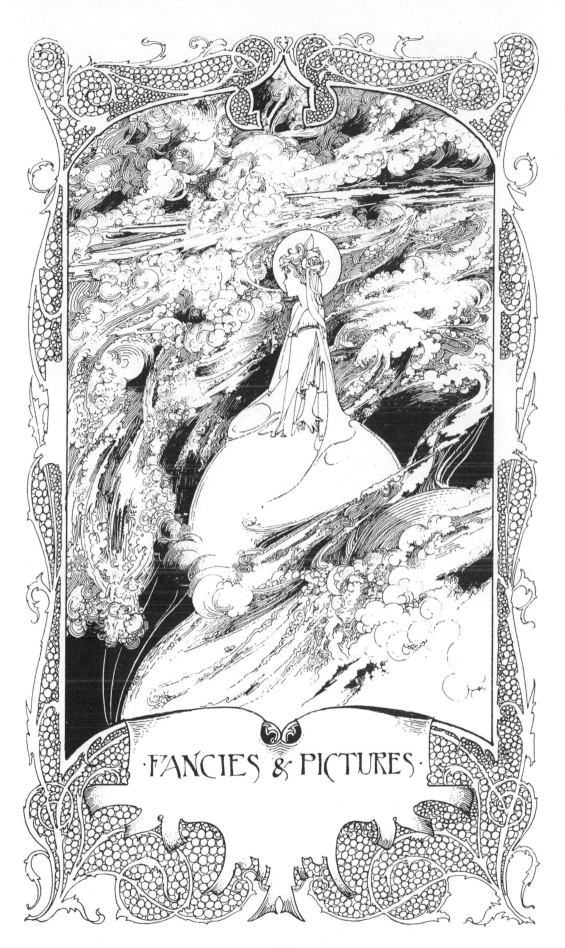

·FANCIES & PICTURES·

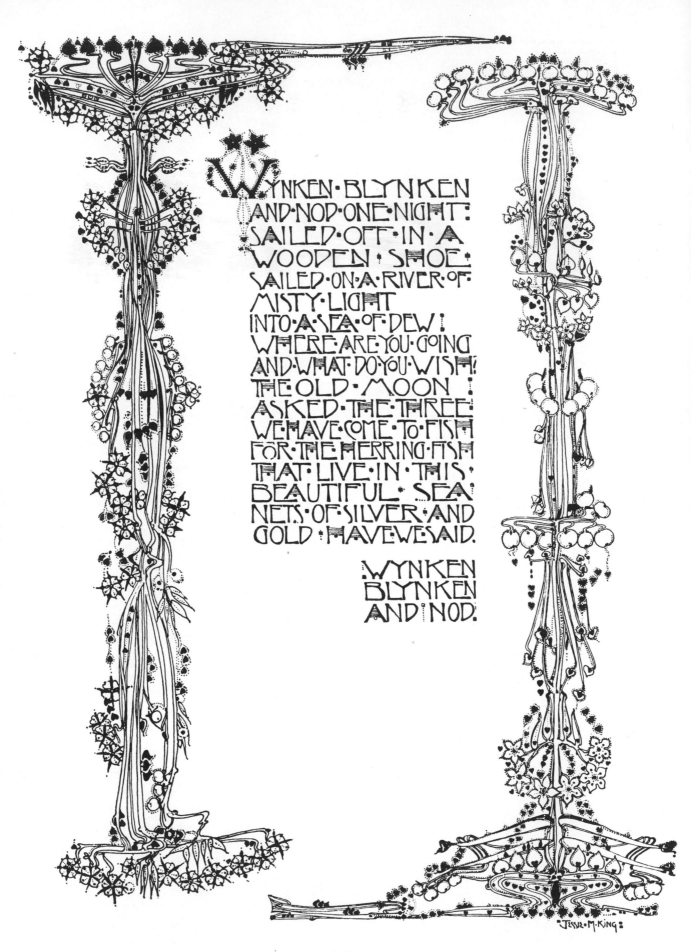

Wynken, Blynken
and Nod one night:
Sailed off in a
wooden shoe:
Sailed on a river of
misty light
Into a sea of dew!
Where are you going
and what do you wish!
The old moon
asked the three
We have come to fish
for the herring fish
That live in this
beautiful sea:
Nets of silver and
gold have we said.

Wynken
Blynken
and Nod.

OLD WORLD
SCOTLAND
GLIMPSES OF
ITS MODES
& MANNERS
T. F. HENDERSON

NEMO ME IMPUNE LACESSET

38

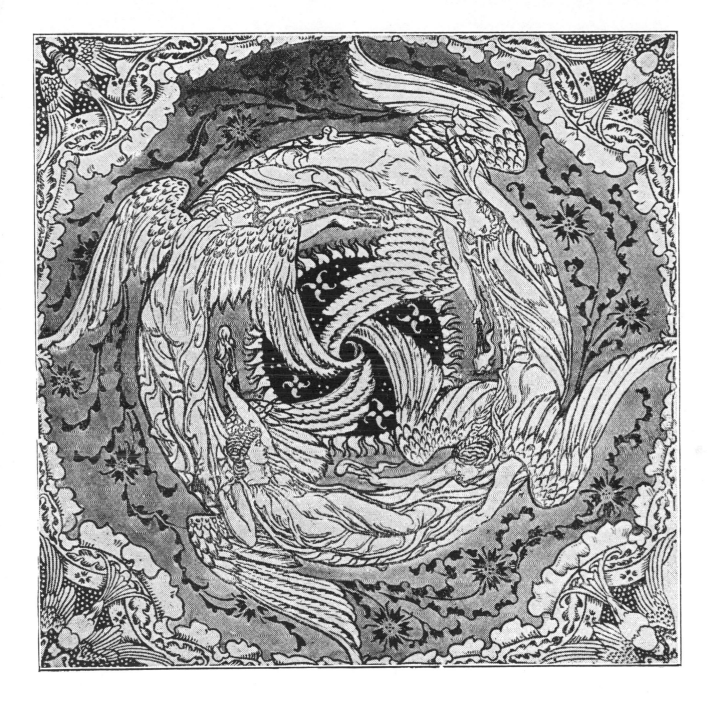

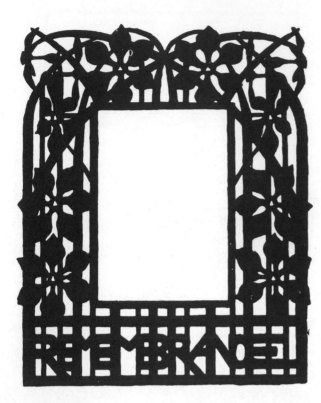

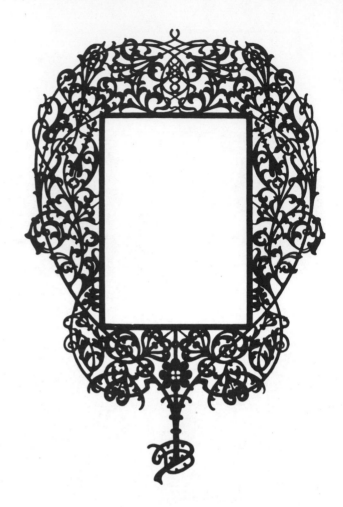

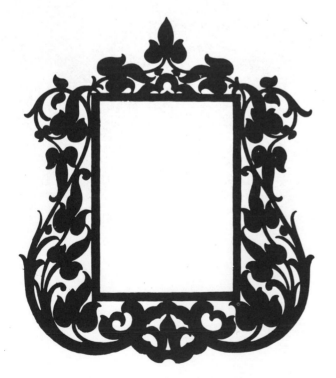

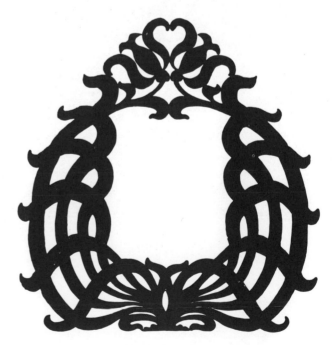

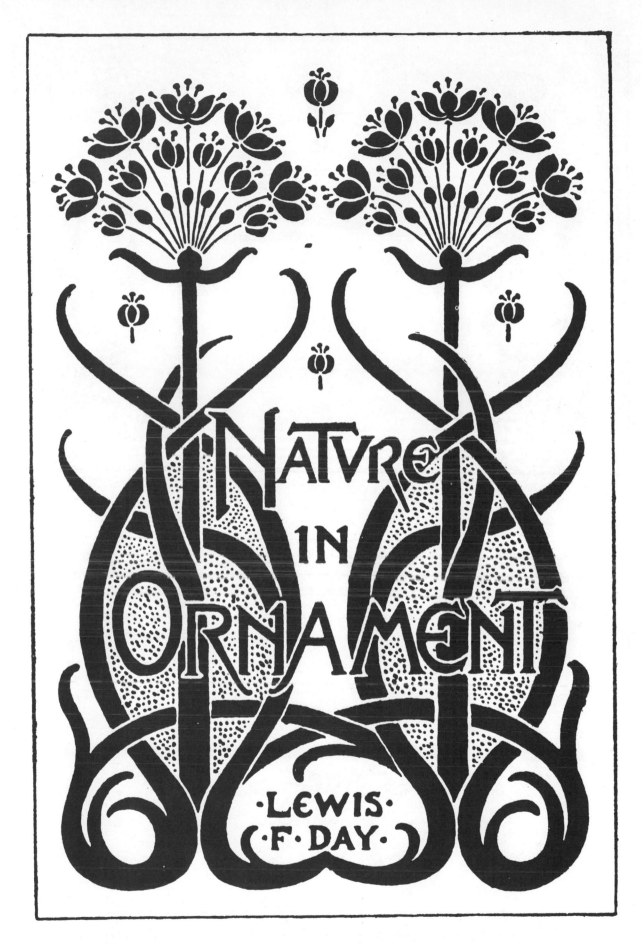

NATVRE IN ORNAMENT

·LEWIS· ·F·DAY·

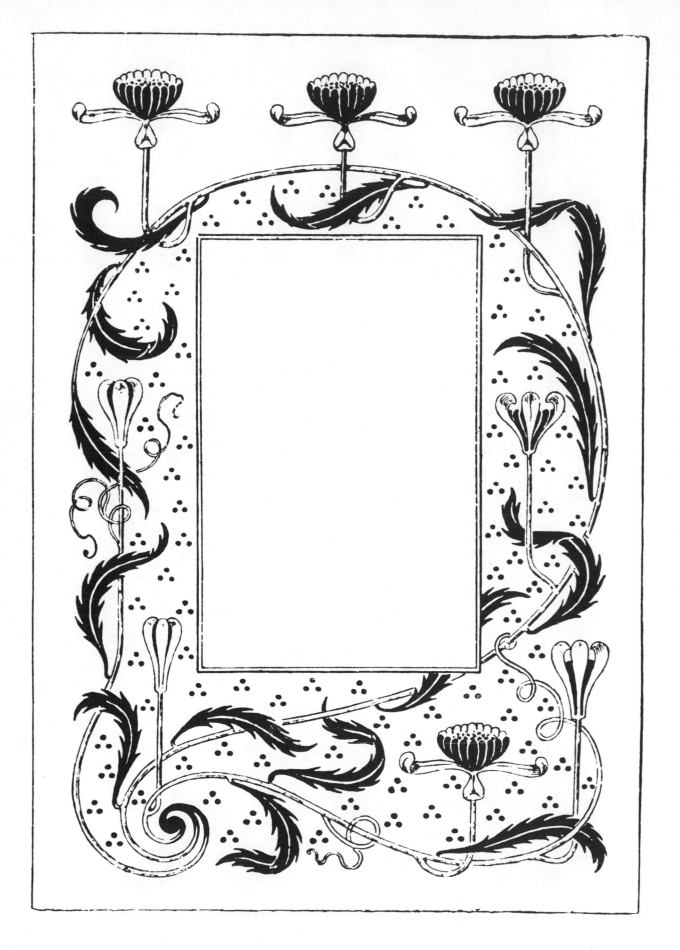

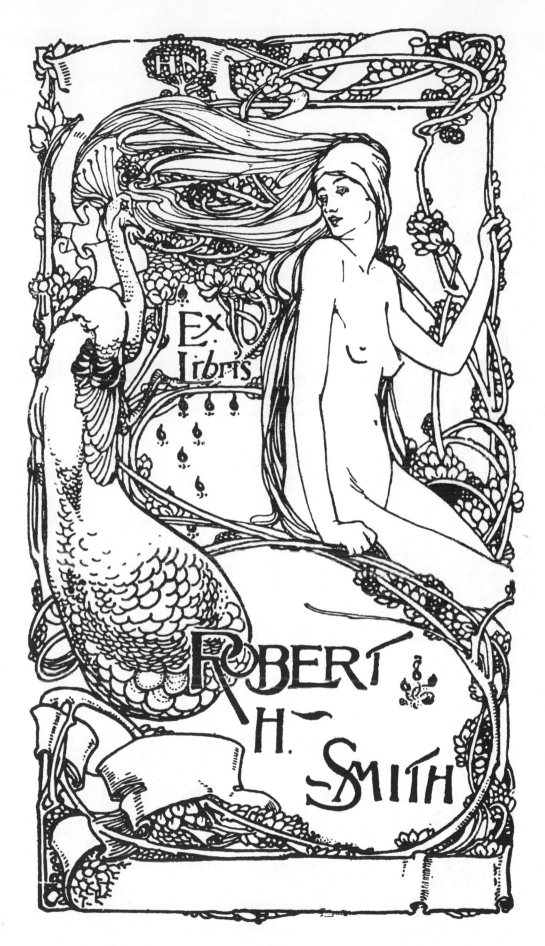

EX Librs

Robert H. Smith

EX LIBRIS

HON MARY FRANCES
HARRIET BORTHWICK

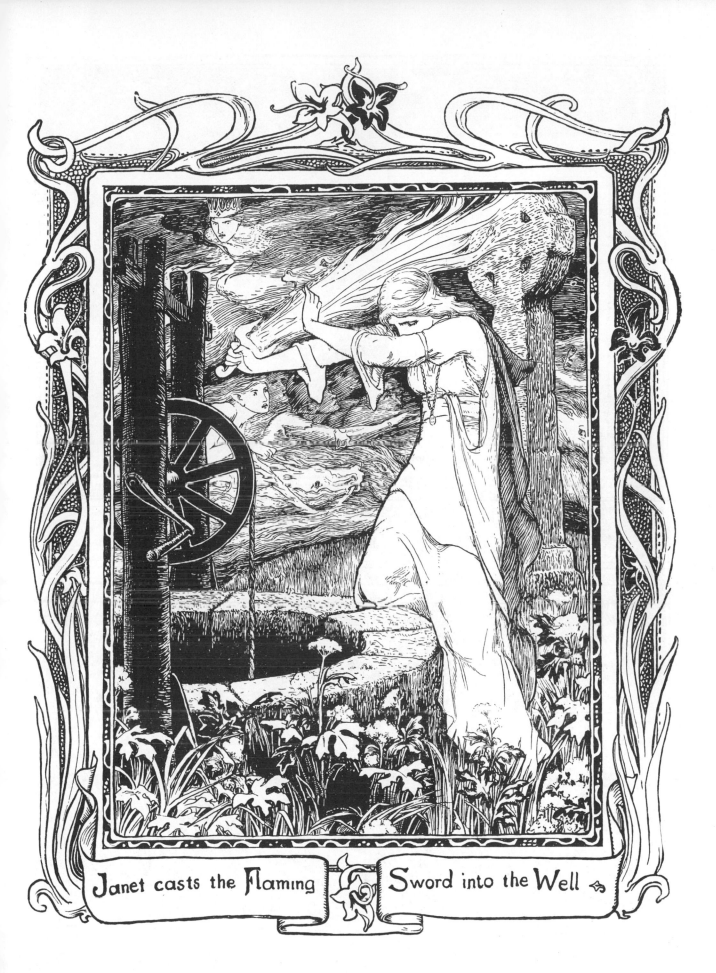

Janet casts the Flaming Sword into the Well

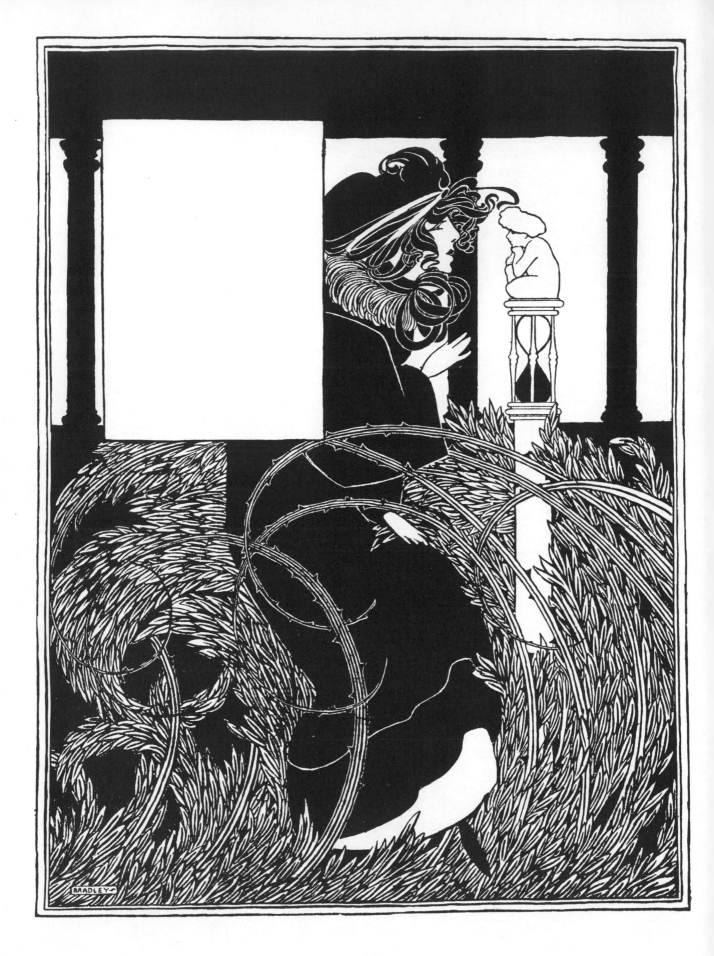

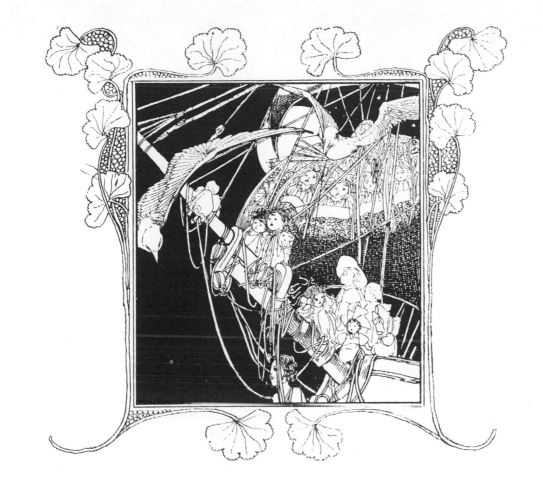

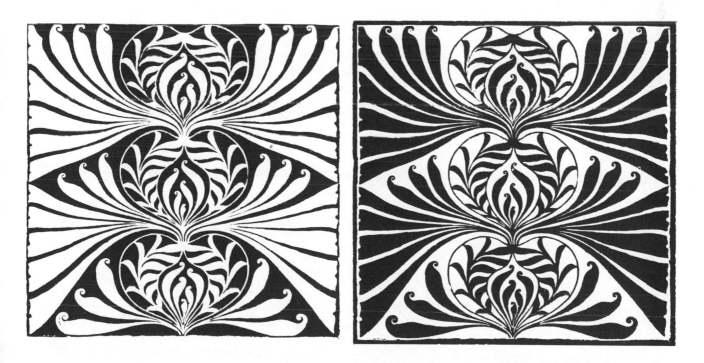

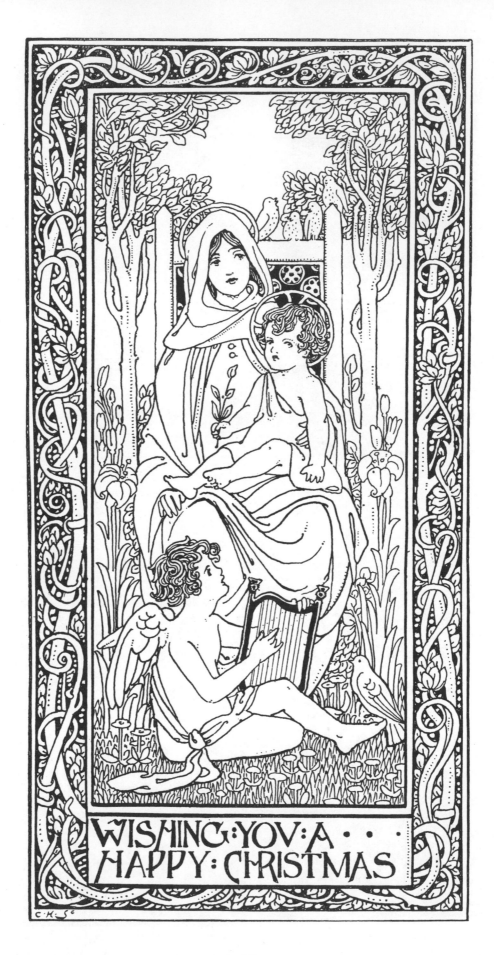

48

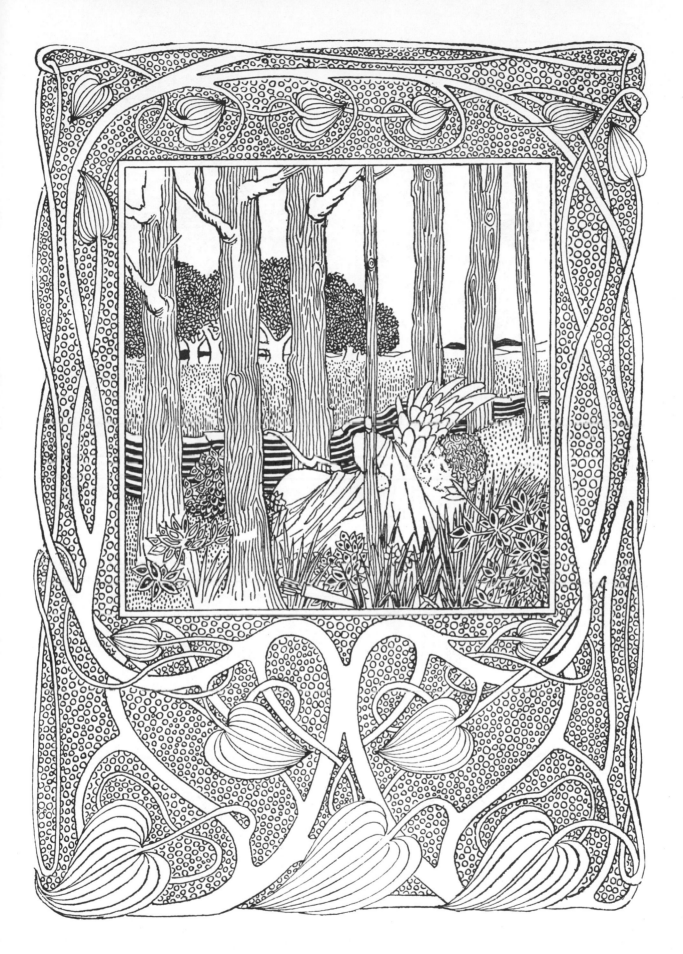

49

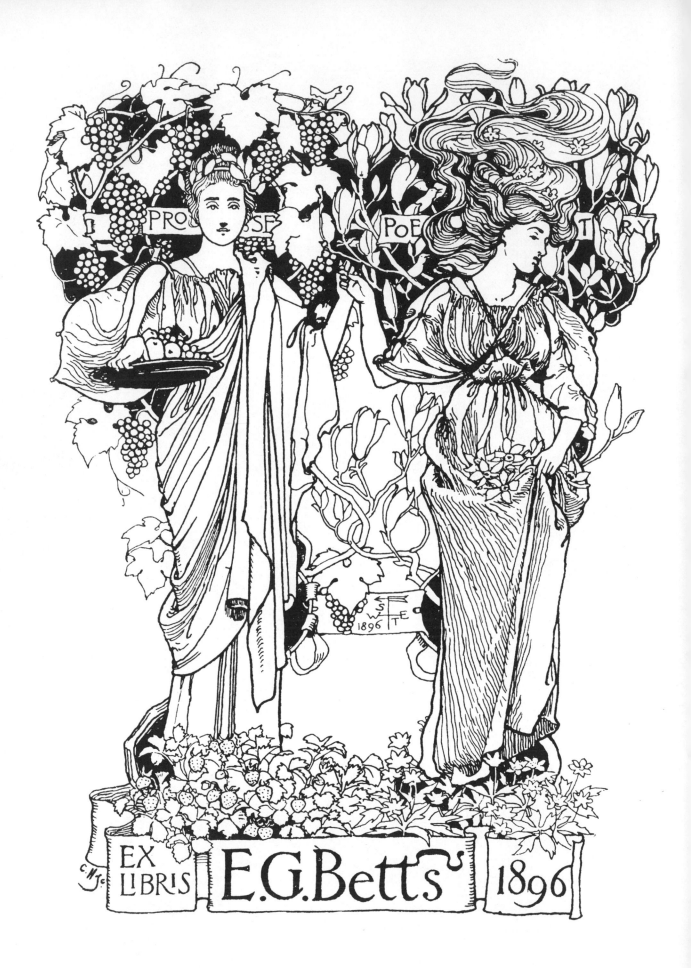

EX LIBRIS E.G.Betts 1896

 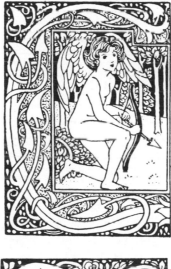 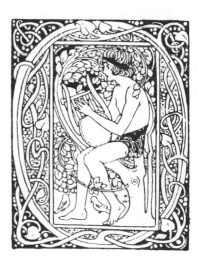

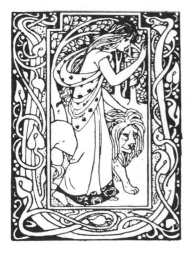 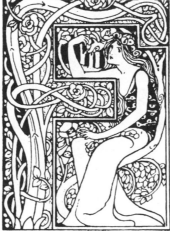

AN
EARTHLY
PARADISE

WESTON

TOLD·IN·A·GARDEN

ART·NOTES·
FOR 1896.

54

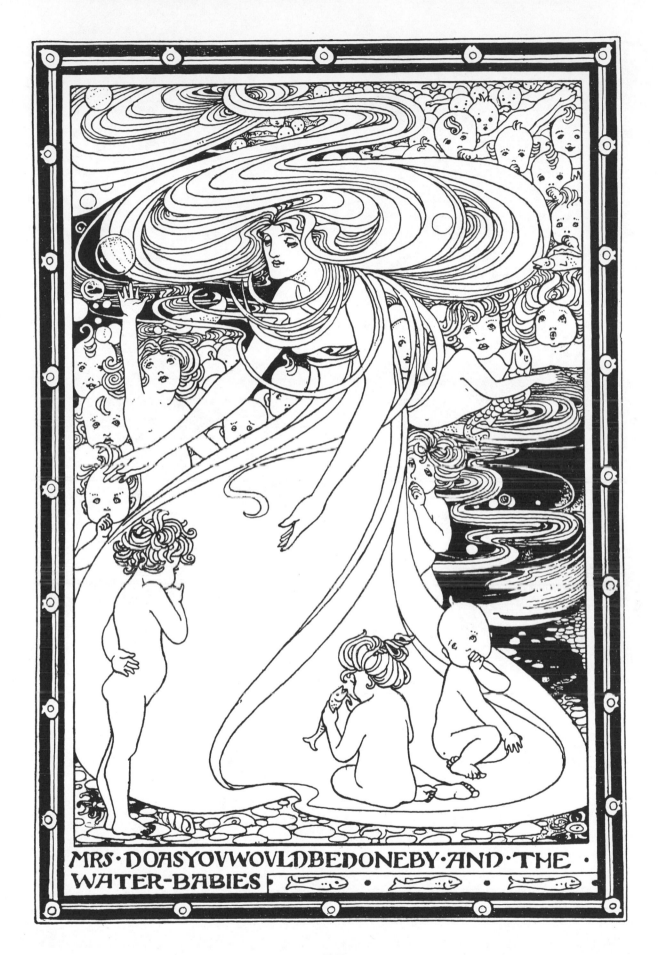

MRS·DOASYOVWOVLDBEDONEBY·AND·THE·
WATER-BABIES·

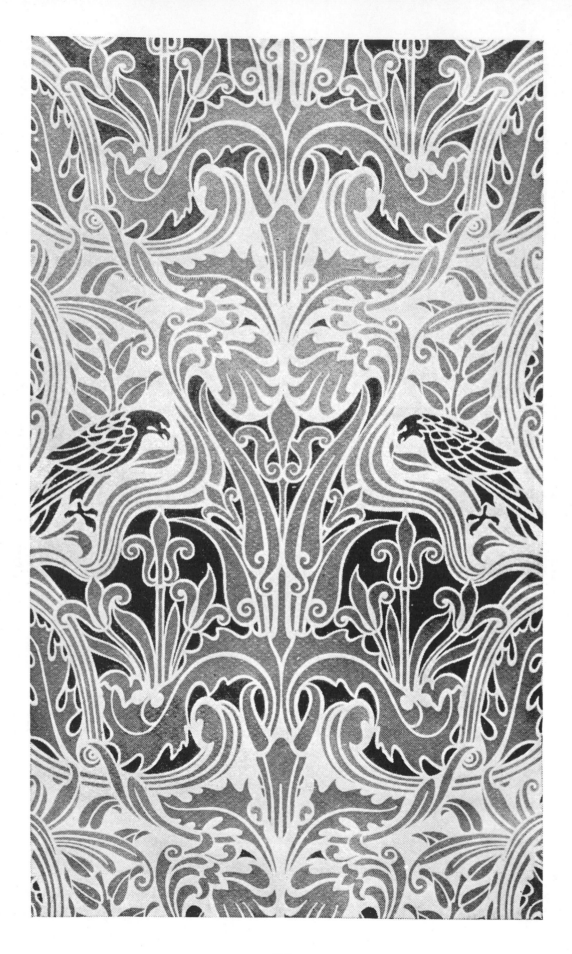

56

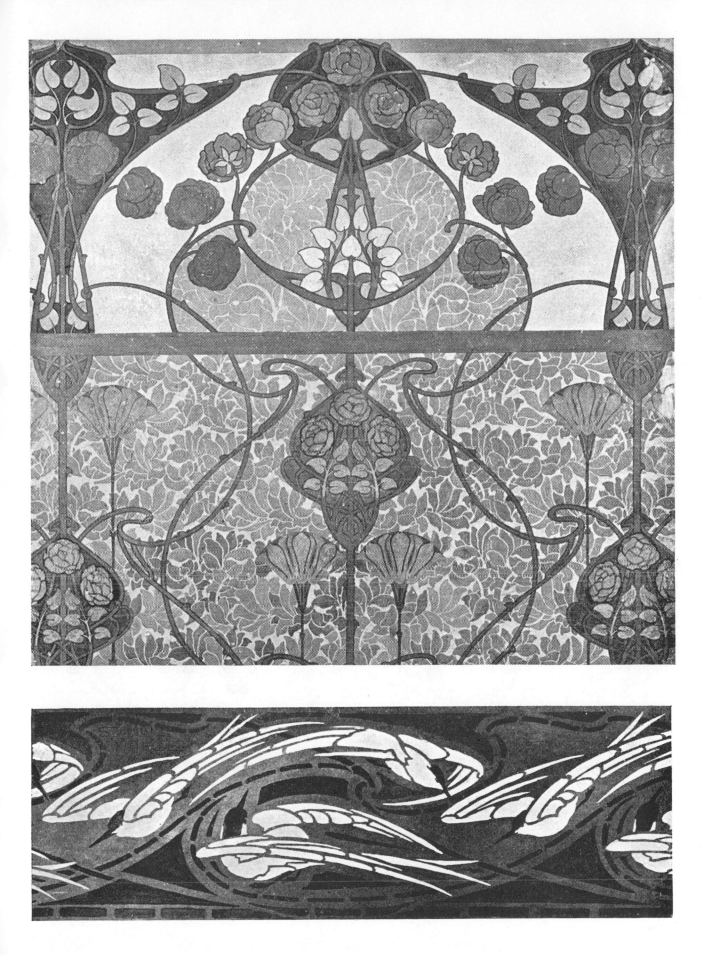

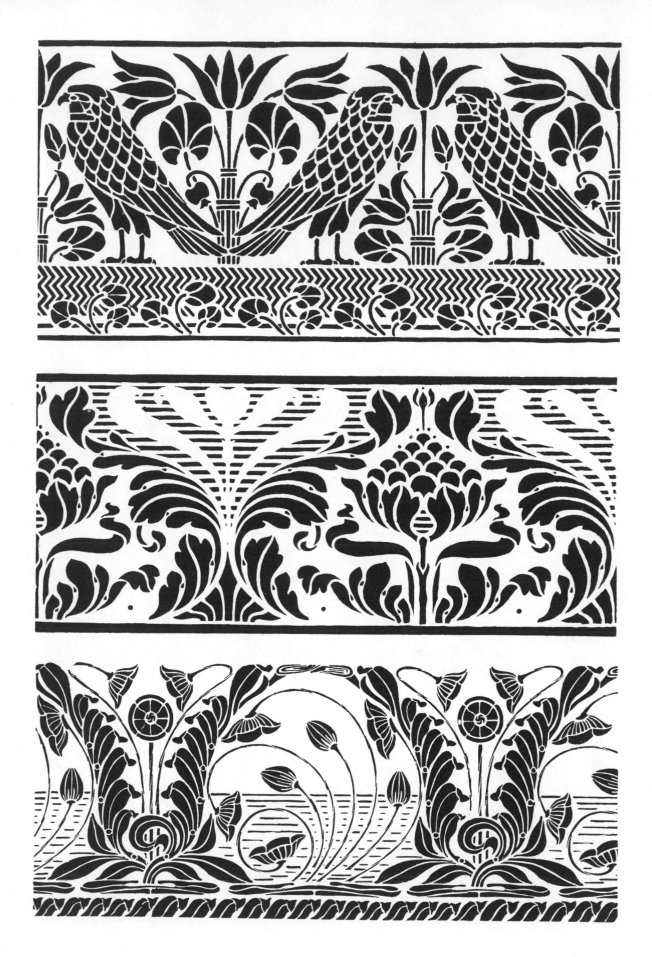

58

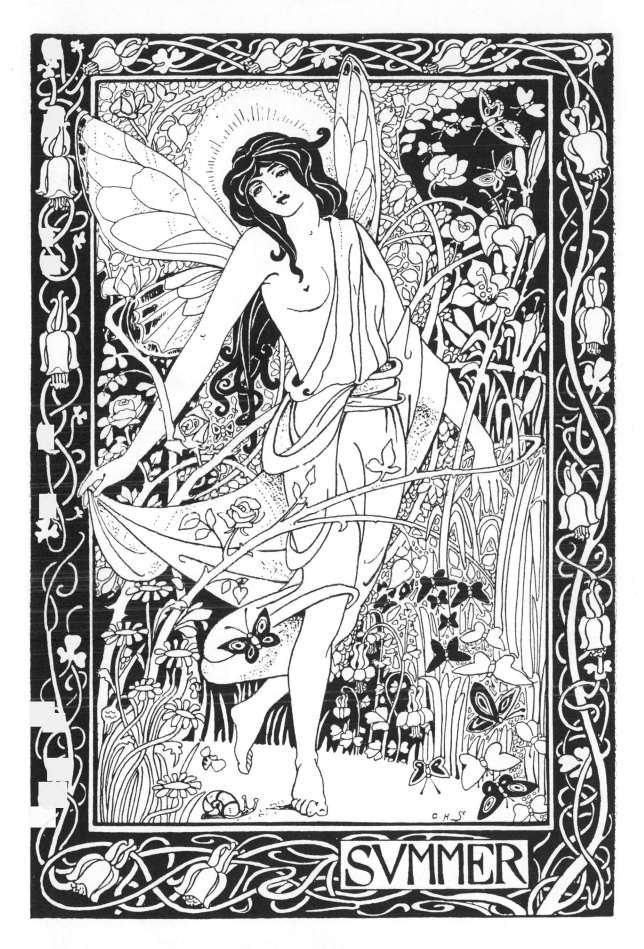

SVMMER

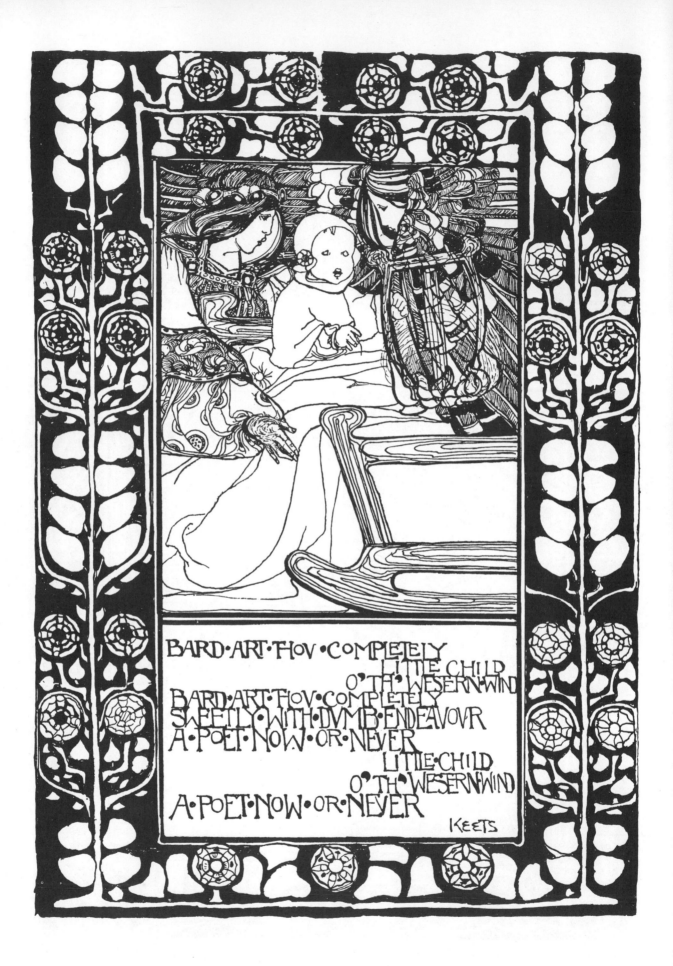

BARD·ART·HOV·COMPLETELY
LITTLE·CHILD
O'·TH'·WESERN·WIND
BARD·ART·HOV·COMPLETELY
SWEETLY·WITH·DVMB·ENDEAVOVR
A·POET·NOW·OR·NEVER
LITTLE·CHILD
O'·TH'·WESERN·WIND
A·POET·NOW·OR·NEVER
KEETS

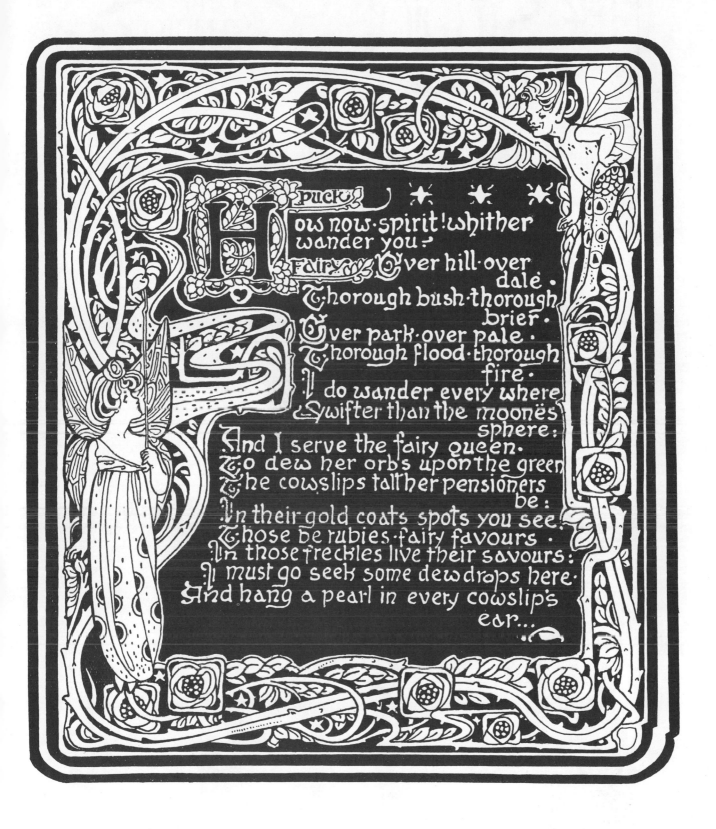

Puck. How now spirit! whither wander you?

Fairy. Over hill over dale.
Thorough bush thorough brier.
Over park over pale.
Thorough flood thorough fire.
I do wander every where
Swifter than the moonës sphere:
And I serve the fairy queen.
To dew her orbs upon the green
The cowslips tall her pensioners be:
In their gold coats spots you see.
Those be rubies fairy favours.
In those freckles live their savours:
I must go seek some dewdrops here.
And hang a pearl in every cowslip's ear...

61

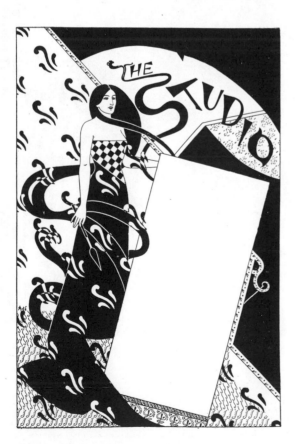

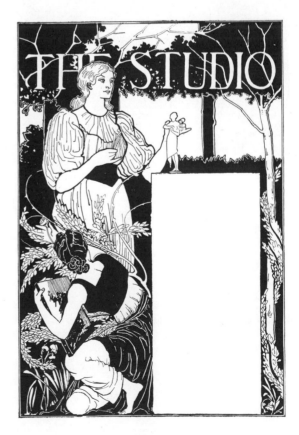

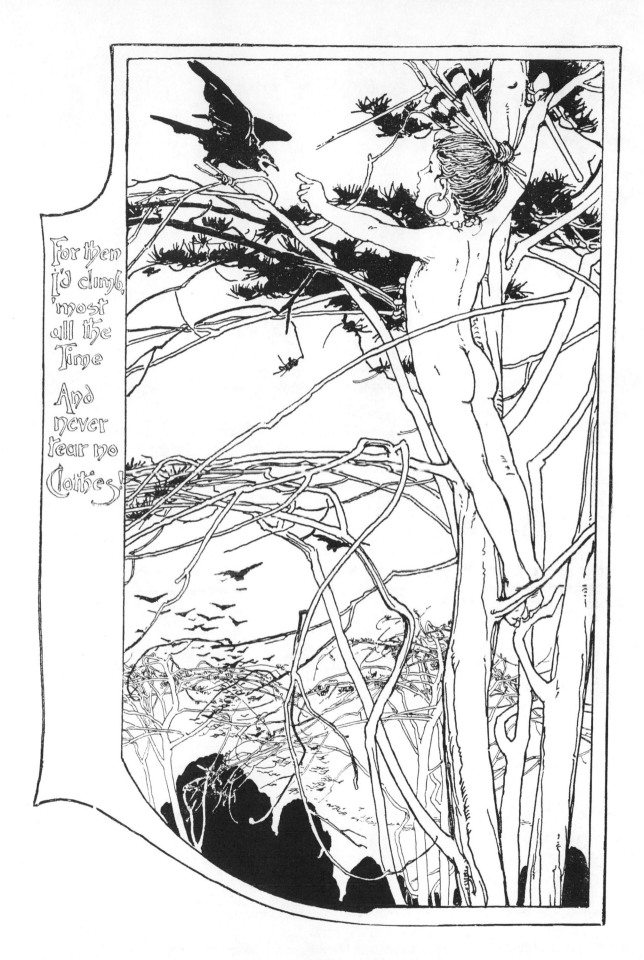

For then I'd climb, 'most all the Time And never tear no Clothes!

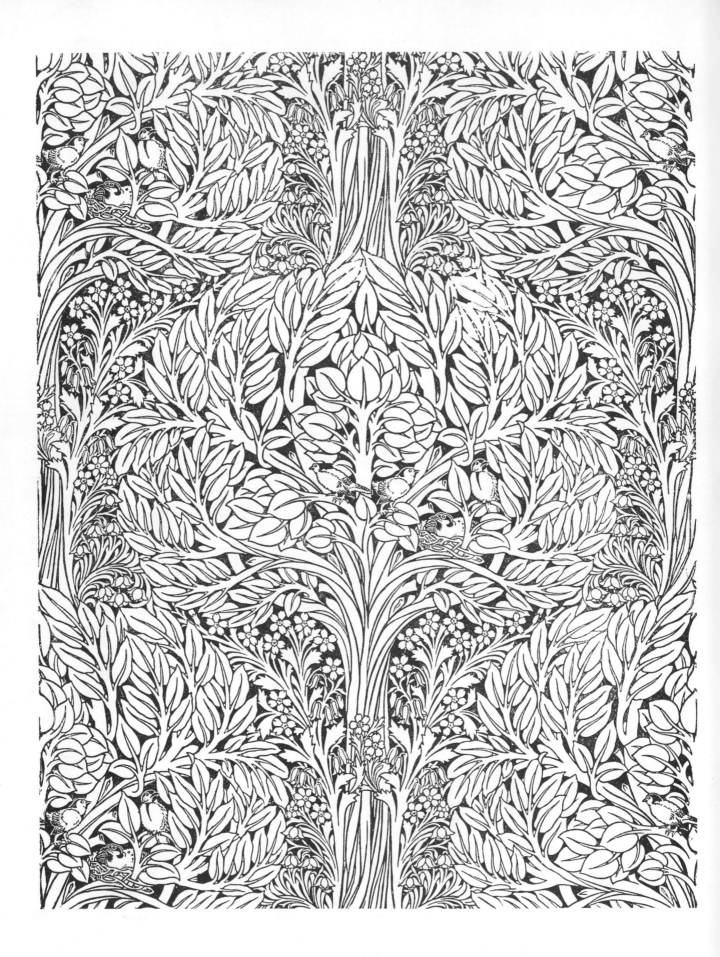

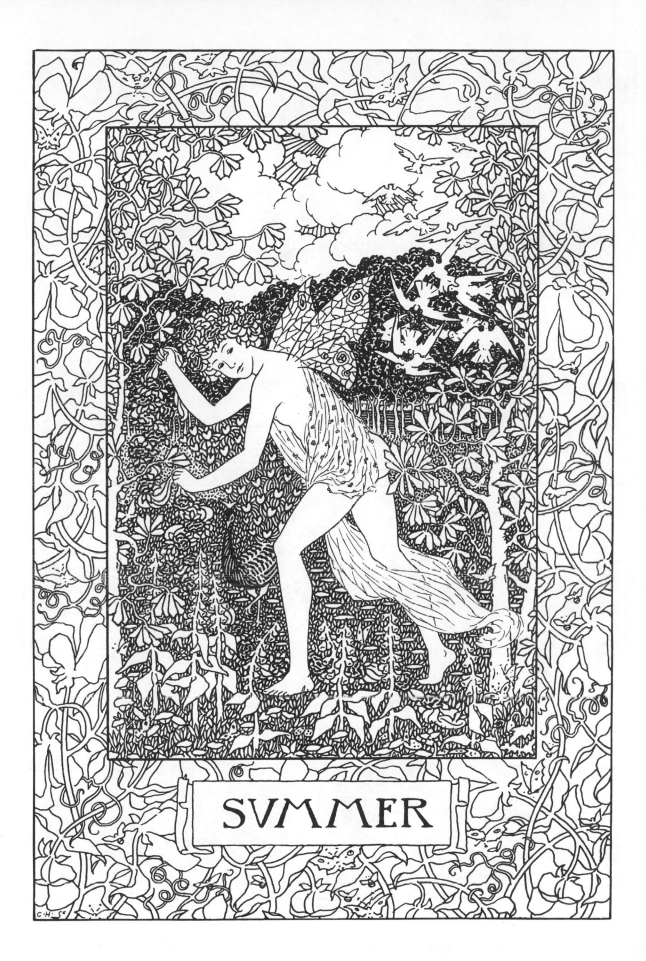

SVMMER

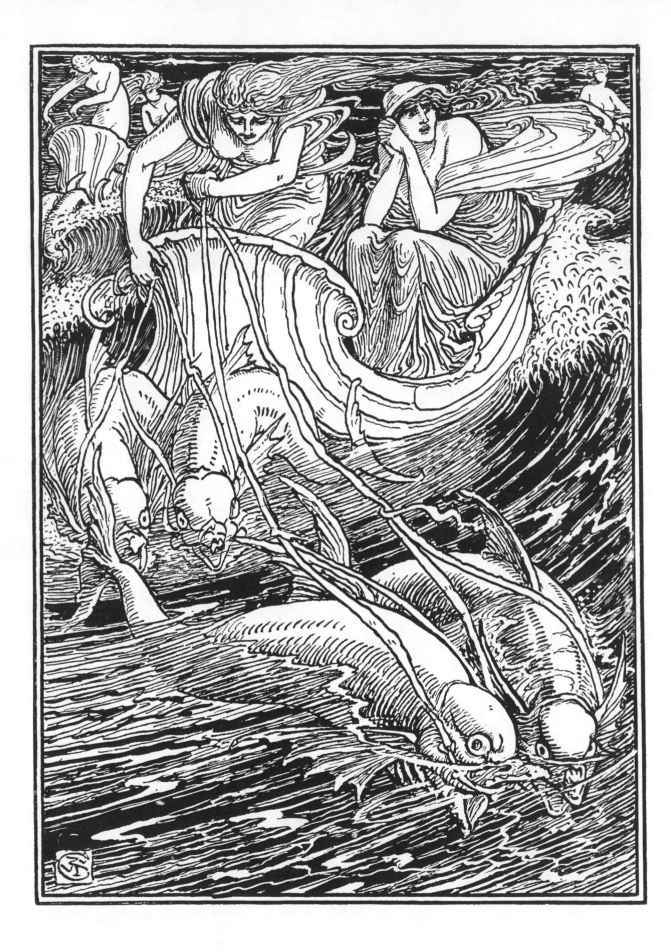

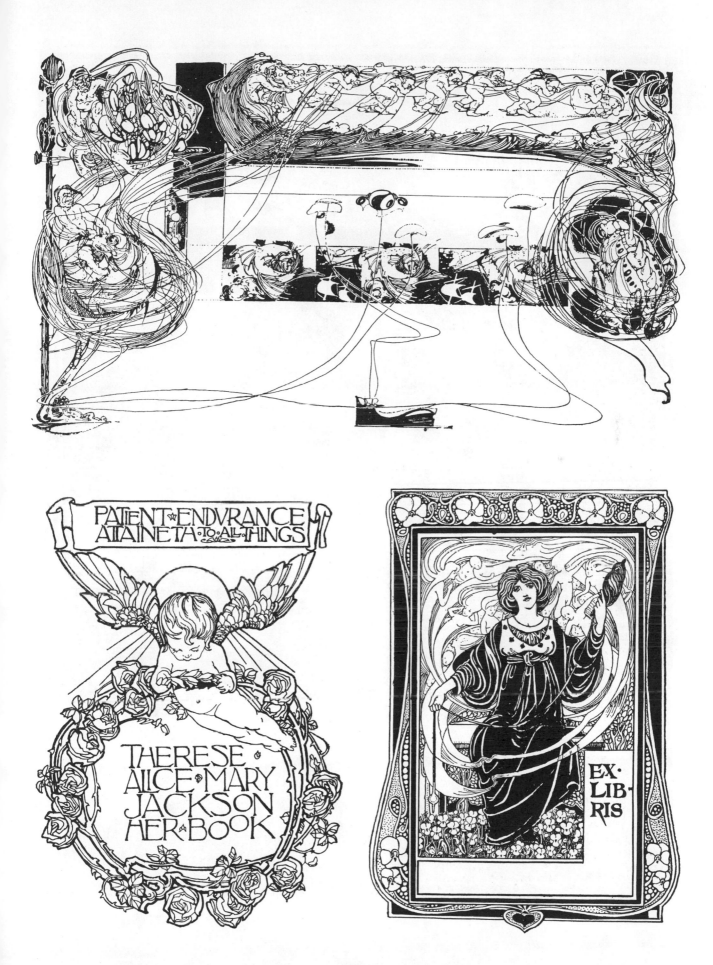

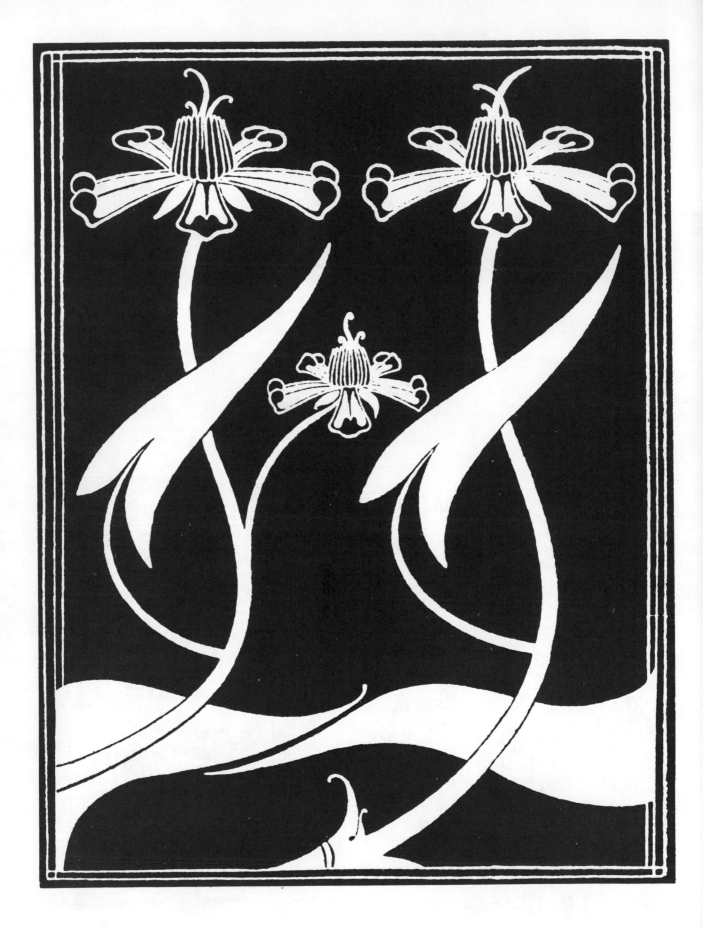

68

THE·CHISWICK
SHAKESPEARE

AS·YOU·LIKE·IT

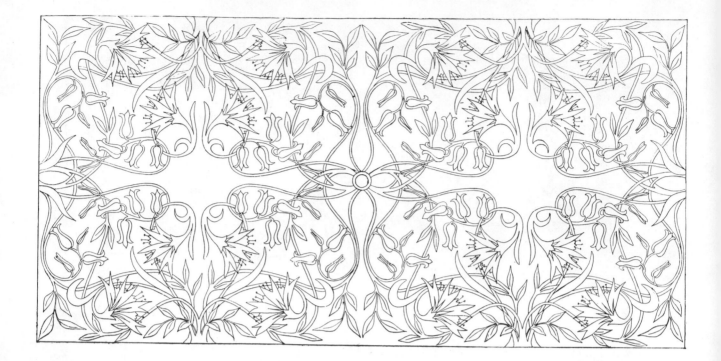

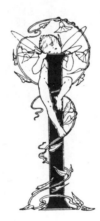

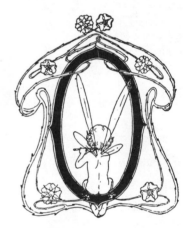

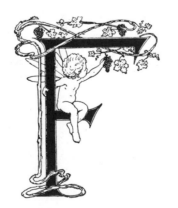

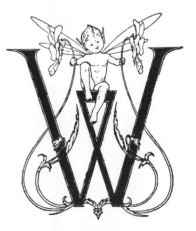

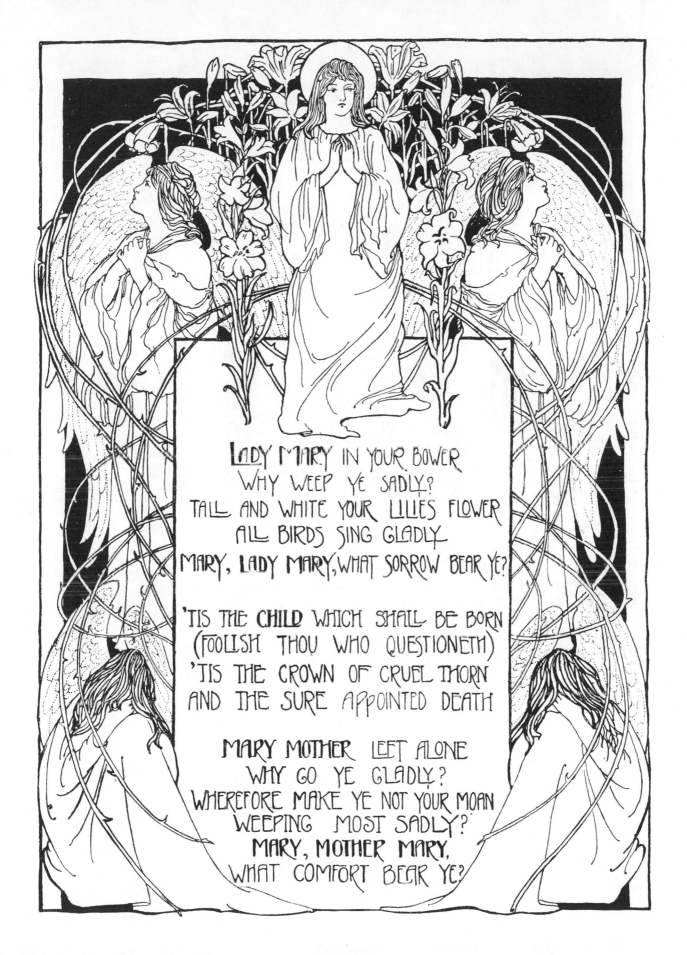

LADY MARY IN YOUR BOWER
WHY WEEP YE SADLY?
TALL AND WHITE YOUR LILIES FLOWER
ALL BIRDS SING GLADLY
MARY, LADY MARY, WHAT SORROW BEAR YE?

'TIS THE CHILD WHICH SHALL BE BORN
(FOOLISH THOU WHO QUESTIONETH)
'TIS THE CROWN OF CRUEL THORN
AND THE SURE APPOINTED DEATH

MARY MOTHER LEFT ALONE
WHY GO YE GLADLY?
WHEREFORE MAKE YE NOT YOUR MOAN
WEEPING MOST SADLY?
MARY, MOTHER MARY,
WHAT COMFORT BEAR YE?

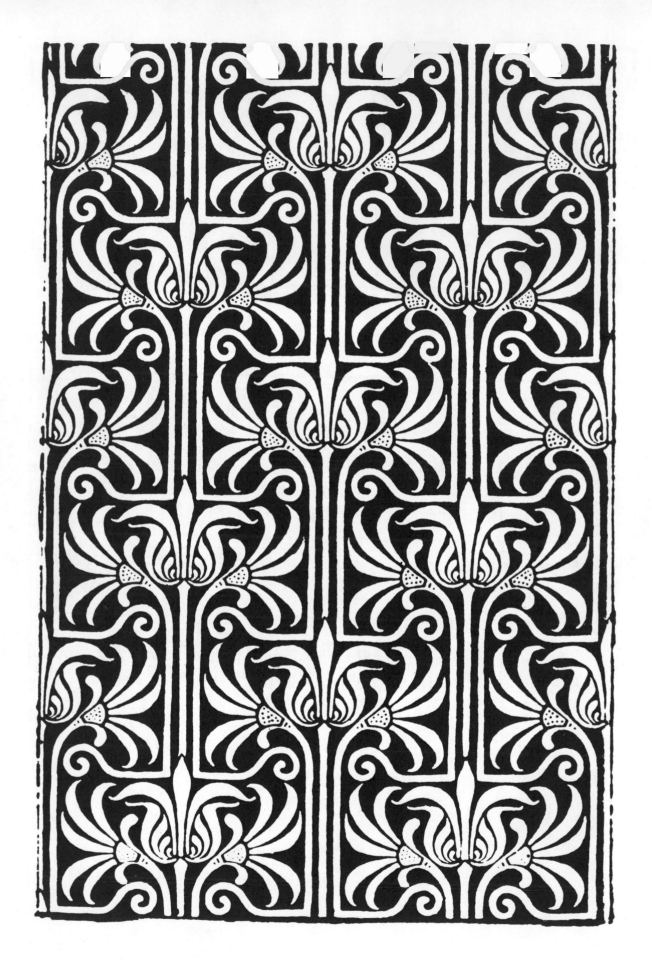

72

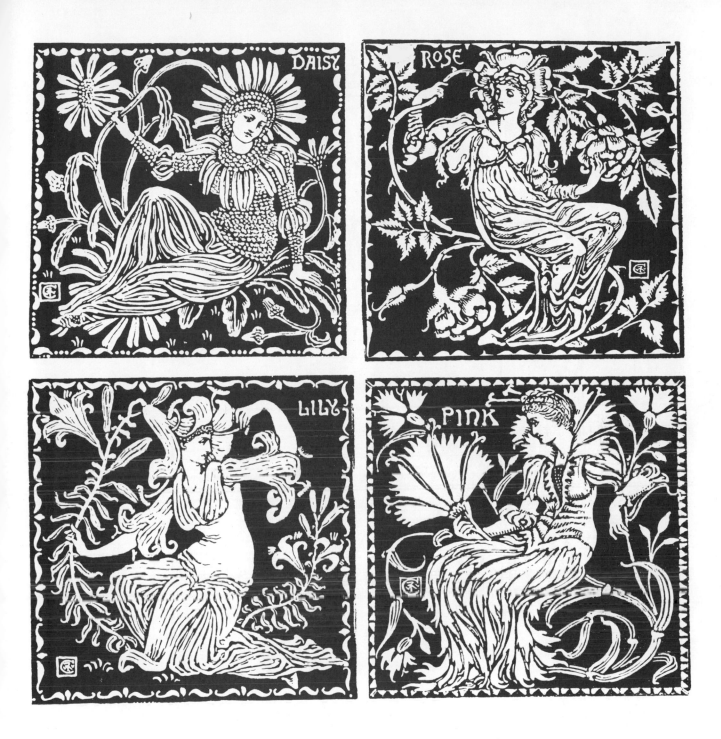

73

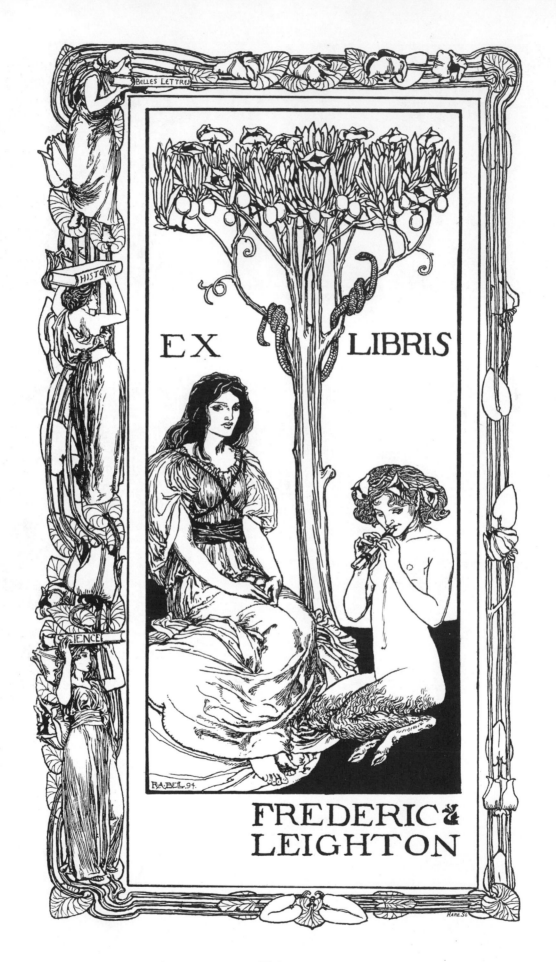

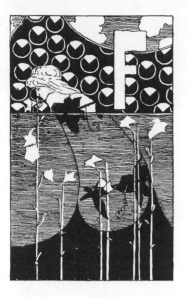
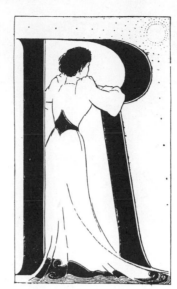
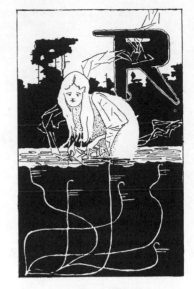
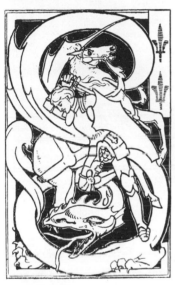

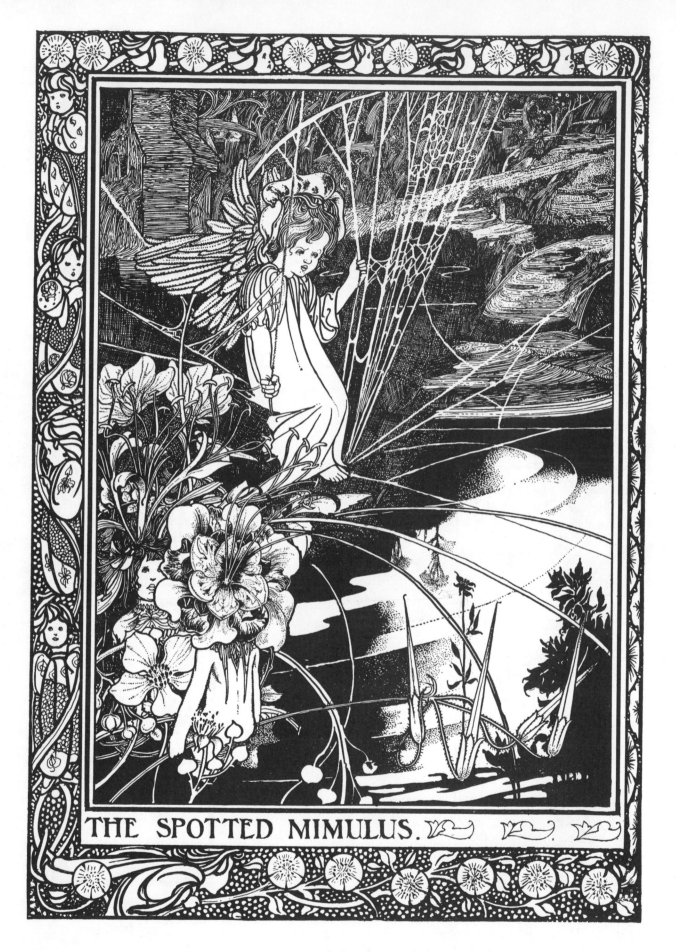

THE SPOTTED MIMULUS.

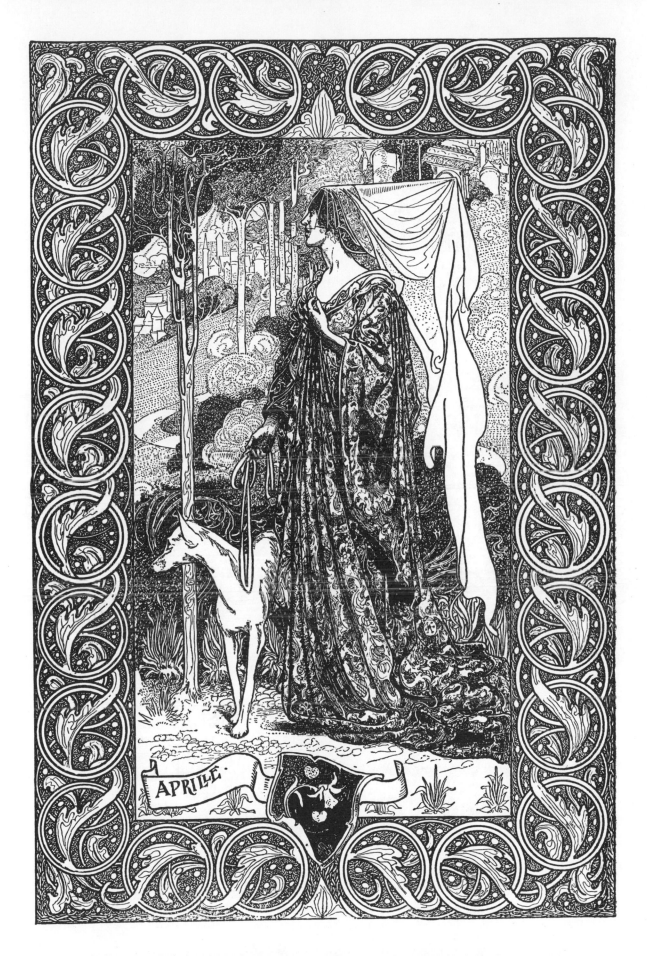

APRILLE·

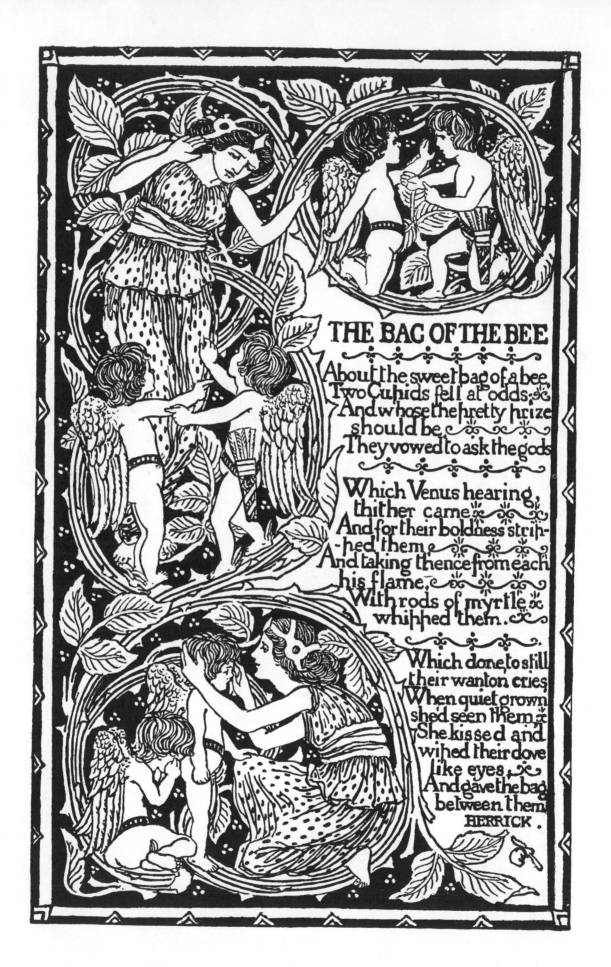

THE BAG OF THE BEE

About the sweet bag of a bee,
Two Cupids fell at odds;
And whose the pretty prize
should be,
They vowed to ask the gods.

Which Venus hearing,
thither came,
And for their boldness strip-
ped them,
And taking thence from each
his flame,
With rods of myrtle
whipped them.

Which done to still
their wanton cries,
When quiet grown
she'd seen them,
She kissed and
wiped their dove-
like eyes,
And gave the bag
between them.
HERRICK.

78

"SO NOW 'TIS ENDED LIKE AN OLD WIFE'S STORY"

HANS SACHS,

HIS LIFE AND WORK · BY H. TEUFELSDROCH

THE
END

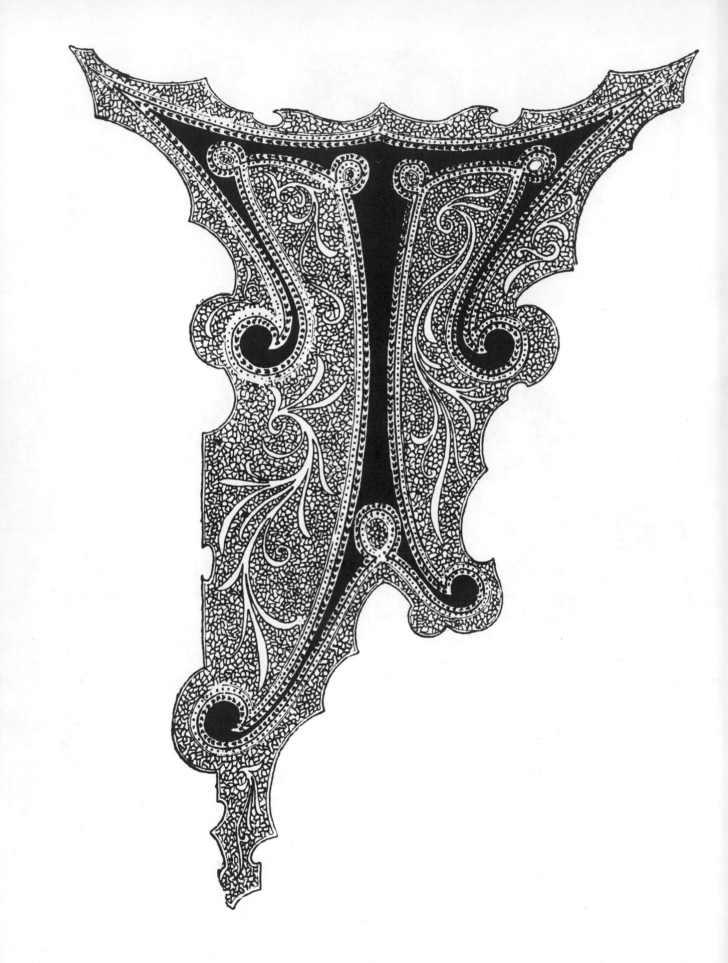

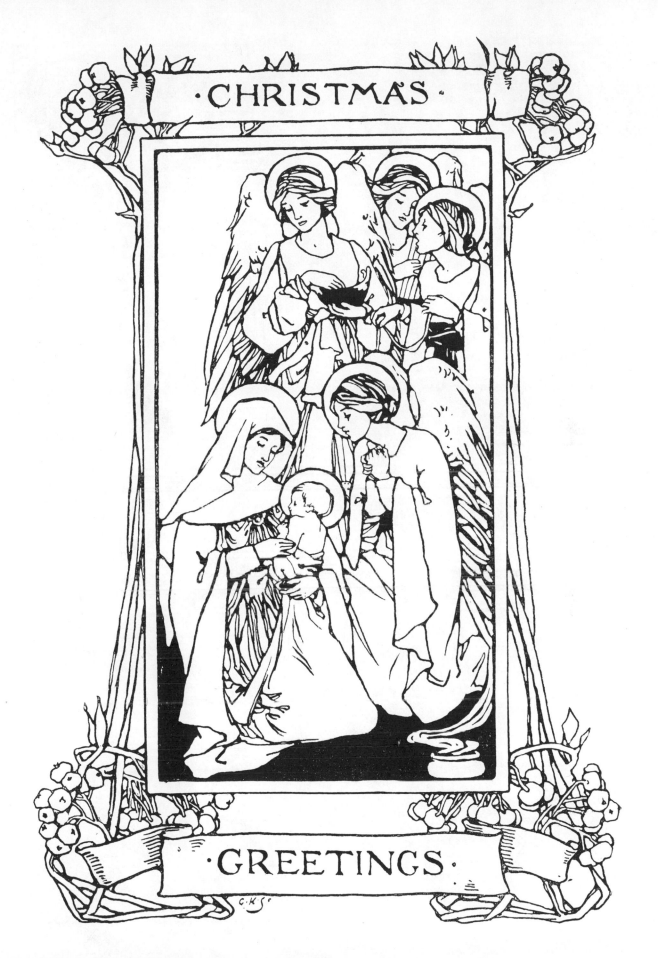

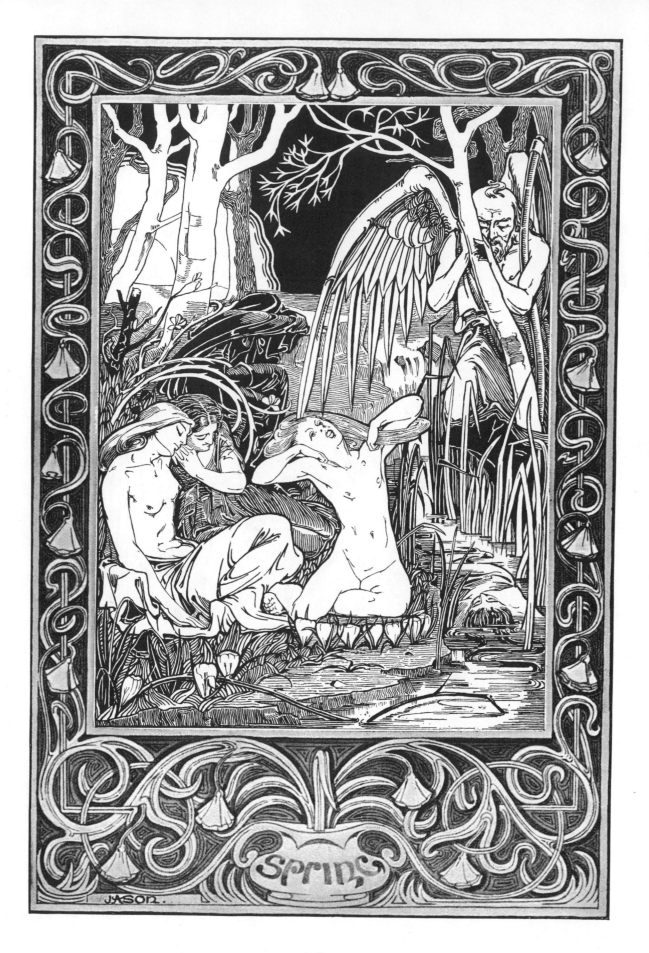

 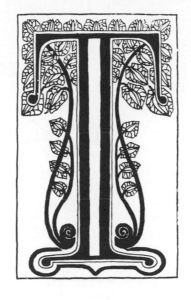 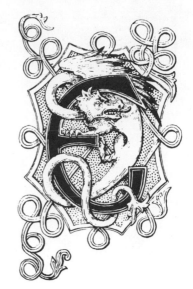

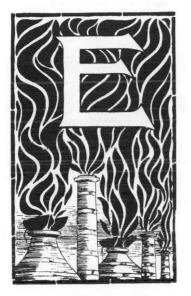 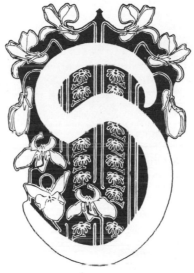

Sources of Illustrations
and Identification of Artists

This list identifies the volume, issue, date and page of *The Studio* in which the illustrations originally appeared. It should be noted that many of the works were competitive designs and were submitted to *The Studio* under pseudonyms; hence the discrepancy between the signatures on the pictures themselves and the following artist identifications.

PLATE

1 *VIII, 39, June 1896, p. 57.* By E. L. Pattison.

2 *XX, 89, August 1900, p. 198.* By Christine Angus.

3 *IV, 19, October 1894, p. III.* TOP (FROM LEFT TO RIGHT): by Evelyn Holden, C. A. Allen, Winifred Sandys. MIDDLE (FROM LEFT TO RIGHT): by Florence A. F. Phillips, Peter C. Brown, Isabel Brittain. BOTTOM (FROM LEFT TO RIGHT): by Henry C. Graff, Albert W. Shingleton, John C. Hall.

4 *XVIII, Special Winter Number, 1899–1900, p. 10.* By Reginald Knowles.

5 *VII, 38, May 1896, p. 255.* TOP: by Arthur Cooke. BOTTOM: by Florence S. K. Joyce.

6 *VIII, 41, August 1896, p. 186.* By Mary G. Houston.

7 *IV, 20, November 1894, p. XV.* FROM TOP TO BOTTOM: by A. L. Duthie, L. C. Radcliffe, W. Benson.

8 *XIV, 65, August 1898, p. 181.* By P. J. Billinghurst.

9 *IX, 43, October 1896, p. 64.* By Charles Ricketts.

10 BOTTOM: *III, 17, August 1894, p. 145.* By H. Pepper. Remaining designs from *XV, 67, October 1898, p. 67.* TOP LEFT: by Eleanor V. Tyler. TOP RIGHT: by Mary Bailey. MIDDLE LEFT: by Alice M. Courtenay. MIDDLE RIGHT: by Ethel Poppleton.

11 *VIII, 42, September 1896, p. 252.* By T. H. Wakefield.

12 *XV, 70, January 1899, p. 293.* FROM TOP TO BOTTOM: by Harold Chas. Bareham, A. T. Griffith, W. R. Bullmore (design shown in negative).

13 *XV, 69, December 1898, p. 215.* By G. R. Quested.

14 *IX, 45, December 1896, p. 218.* Drawing by Charles Robinson for *The Child World*.

15 *XV, Special Winter Number, 1898–9, pp. 5 and 7.* LEFT: by Charles Robinson. RIGHT: by Harold Nelson.

16 *XV, Special Winter Number, 1898–9, p. 3.* By Cyril Goldie.

17 *IV, 20, November 1894, p. XIII.* FROM TOP TO BOTTOM: by S. Hewer, H. C. Graff, S. Winifield Rhodes.

18 *XXI, 93, December 1900, p. 219.* By Scott Calder.

19 *XI, 52, July 1897, p. 137.* TOP LEFT: by Mary G. Simpson. TOP RIGHT: by Sarah MacConnell. BOTTOM LEFT: by E. L. Pattison. BOTTOM RIGHT: by Thomas Henry.

20 *XVIII, Special Winter Number, 1899–1900, p. 18.* By A. A. Turbayne.

21 *VII, 36, March 1896, p. 97.* By Arthur Maude.

22 TOP: *XVIII, 82, January 1900, p. 298.* By John Thirtle. Remaining designs from *XXI, 91, October 1900, p. 72.* All by E. Pay.

23 *X, 48, March 1897, p. 115.* By R. H. Bradley.

24 *XVI, 71, February 1899, p. 69.* Illustration by Laurence Housman for *The Field of Clover*.

25 TOP: *XVII, 78, September 1899, p. 269.* Both by Frank M. Jones. BOTTOM: *XV, 70, January 1899, p. 293.* By W. R. Bullmore.

26 TOP: *XX, 87, June 1900, p. 66.* Both by Ethel Larcombe. BOTTOM: *XII, 55, October 1897, p. 66.* By John Thirtle.

27 *VIII, 41, August 1896, p. 190.* By May Dixon.

28 *XVIII, Special Winter Number, 1899–1900, p. 2.* By W. H. Cowlishaw.

29 *XII, 58, January 1898, p. 287.* TOP LEFT: by Alice B. Burt. TOP RIGHT: by A. de Sauty. BOTTOM: *XIV, 66, September 1898, p. 269.* By Ernest Simpson.

30 *VIII, 41, August 1896, p. 185.* By John Thirtle.

31 *IV, 20, November 1894, p. XII.* FROM TOP TO BOTTOM: by George R. Rigby, H. C. Graff, S. Winifred Rhodes.

32 *XV, Special Winter Number, 1898–9, p. 18.* By P. J. Billinghurst.

33 *IX, 43, October 1896, p. 74.* Illustration by Charles Robinson for *The Child World*.

34 *XV, 70, January 1899, pp. 278–79.* By Jessie M. King.

35 *VIII, 39, June 1896, p. 57.* By T. S. Galbraith.

36 *VIII, 39, June 1896, pp. 55–56.* TOP LEFT: by Juliet Williams. TOP RIGHT: by F. E. Tomlinson. BOTTOM LEFT: by Mabel Syrett. BOTTOM RIGHT: by J. M. Doran.

37 *VIII, 39, June 1896, p. 54.* By Will Bradley.

38 *III, 18, September 1894, p. XI.* By C. R. Warren.

39 *IV, 21, December 1894, p. 79.* By Walter Crane.

40 *VIII, 39, June 1896, p. 60.* TOP LEFT: by Margaret D. Stubbs. TOP RIGHT: by Alfred C. Hooker. BOTTOM LEFT: by Harold Moorecraft. BOTTOM RIGHT: by G. S. Tanner.

41 *VIII, 39, June 1896, p. 56.* By Charles A. Allen.

42 *VIII, 39, June 1896, p. 56.* By Herbert Dobby.

43 *XV, Special Winter Number, 1898–9, p. 36.* By H. Nelson.

44 *VII, 36, March 1896, p. 95.* By R. Anning Bell.

Sources of Illustrations and Identification of Artists

45 *XII, Special Winter Number, 1897–8, p. 34.* Illustration by J. D. Batten for *English Fairy Tales*.

46 *IV, 23, February 1895, p. 166.* Illustration by W. H. Bradley for *The Chicago Sunday Tribune*.

47 TOP: *IX, 45, December 1896, p. 217.* Illustration by Charles Robinson for *The Child World*. BOTTOM: *II, 10, January 1894, p. 149.* By C. H. B. Quennel (at the left the design is shown in negative).

48 *XVIII, 81, December 1899, p. 225.* By Ethel Larcombe.

49 *X, 48, March 1897, p. 141.* Illustration by W. B. MacDougall for *Songs of Love and Death*.

50 *VIII, 39, June 1896, p. 42.* By J. Walter West.

51 TOP: *XV, 67, October 1898, p. 68.* By Enid Jackson. MIDDLE AND BOTTOM: *XXI, 91, October 1900, p. 71.* By F. H. Ball.

52 *XII, Special Winter Number, 1897–8, p. 43.* Illustration by Mary J. Newill for *A Book of Nursery Songs and Rhymes*.

53 *XII, 57, December 1897, p. 186.* By Christopher Dean.

54 *XI, 52, July 1897, p. 135.* TOP LEFT: by Bert Smale. TOP RIGHT: by Herbert Dobby. BOTTOM LEFT: by Emily A. Atwell. BOTTOM RIGHT: by Arthur Maude.

55 *XXI, 92, November 1900, p. 145.* By Ethel Larcombe.

56 *IX, 46, January 1897, p. 271.* By Ingram Taylor (design shown in negative).

57 TOP: *XX, 90, September 1900, p. 259.* By J. J. Whitcombe. BOTTOM: *XV, 70, January 1899, p. 291.* By Mary Wilcock.

58 *IV, 20, November 1894, p. XIV.* FROM TOP TO BOTTOM: by E. A. Hopwood, C. G. Lowther, F. Wilson.

59 *XVII, 75, June 1899, p. 71.* By Ethel Larcombe.

60 *XXI, 93, December 1900, p. 219.* By "Chance."

61 *XXI, 94, January 1901, p. 290.* By Ethel Lacombe.

62 *VI, 33, December 1895, p. 196.* TOP LEFT: by Fred Appleyard. TOP RIGHT: by Louis Bircumshaw. BOTTOM LEFT: by Arthur B. Barrett. BOTTOM RIGHT: by W. B. Handforth.

63 *XII, Special Winter Number, 1897–8, p. 47.* Illustration by Alice B. Woodward for *Red Apple and Silver Bells*.

64 *II, 7, October 1893, p. 22.* By H. Wilson.

65 *VIII, 41, August 1896, p. 187.* By Scott Calder.

66 *IX, 43, October 1896, p. 59.* Illustration by Walter Crane for the *Faerie Queene*.

67 TOP: *XXI, 93, December 1900, p. 176.* By Carton Moore Park. Remaining designs from *XX, 87, June 1900, p. 64.* LEFT: by Enid M. Jackson. RIGHT: by Ethel Larcombe.

68 *IV, 19, October 1894, p. 20.* Design by Aubrey Beardsley for *Morte d'Arthur*, shown in negative.

69 *XVIII, Special Winter Number, 1899–1900, p. 6.* By Gerald Moira.

70 TOP: *IX, 46, January 1897, p. 303.* By Constance M. Lindley. MIDDLE AND BOTTOM: *XXI, 91, October 1900, p. 70.* By Marjory P. Rhodes.

71 *XXI, 94, January 1901, p. 291.* By Claire Murrell.

72 *III, 18, September 1894, p. VII.* By L. F. Day.

73 *II, 7, October 1893, p. 28.* By Walter Crane.

74 *III, 16, July 1894, p. 123.* By R. Anning Bell.

75 *IV, 19, October 1894, p. III.* TOP (FROM LEFT TO RIGHT): by Chas. Pears, George H. Wood, Chas. Pears. MIDDLE (FROM LEFT TO RIGHT): by Harold E. H. Nelson, Amelia Bauerle, Nellie Benson. BOTTOM (FROM LEFT TO RIGHT): by Alfred Fisher, Bertha Smith, Howard S. Adamson.

76 *XII, Special Winter Number, 1897–8, p. 65.* Illustration by Charles Robinson for *King Longbeard*.

77 *XVIII, 81, December 1899, p. 214.* Illustration by Charles Robinson for *The Suitors of Aprille*.

78 *VI, 31, October 1895, p. 35.* By Kate Light.

79 TOP LEFT: *IV, 24, March 1895, p. LII.* By G. R. Quested. MIDDLE LEFT: *III, 17, July 1894, p. 145.* By H. Pepper. Remaining designs from *XX, 89, August 1900, p. 207.* TOP RIGHT: by R. P. Gossop. MIDDLE RIGHT: by H. P. Shapland. BOTTOM LEFT: by Ada Hazel. BOTTOM RIGHT: by E. V. Tyler.

80 *XV, 67, October 1898, p. 68.* By Mary M. Falcon.

81 *XII, 57, December 1897, p. 184.* By Christopher Dean.

82 TOP: *XX, 89, August 1900, p. 206.* By F. C. Davies. BOTTOM: *XV, 67, October 1898, p. 68.* By F. H. Ball.

83 TOP: *XV, 67, October 1898, p. 68.* By F. H. Ball. BOTTOM: *XX, 89, August 1900, p. 206.* By R. P. Gossop.

84 *IV, 19, October 1894, p. V.* By B. A. Lewis.

85 *XV, 70, January 1899, p. 295.* By Fred. H. Ball.

86 *IV, 24, March 1895, p. LII.* TOP RIGHT: by F. Rhead. MIDDLE LEFT: by G. R. Quested. All other designs from *XX, 89, August 1900, p. 206.* TOP LEFT: by Olive Allen. MIDDLE RIGHT: by Janet Simpson. BOTTOM LEFT: Ethel Larcombe. BOTTOM RIGHT: by Ivy Millicent James.

87 *XVIII, 81, December 1899, p. 226.* By Osmond Pittmann.

88 *VII, 38, May 1896, p. 252.* By John Thirtle.

89 *IV, 19, October 1894, pp. II and V.* TOP (FROM LEFT TO RIGHT): by Jesse Berridge, R. J. Williams, Mrs. Blackburn Rane. MIDDLE: by Edgar J. Ransom, R. R. Kidson, C. A. Allen. BOTTOM: by Charles J. White, R. Livesay, H. Nelson.

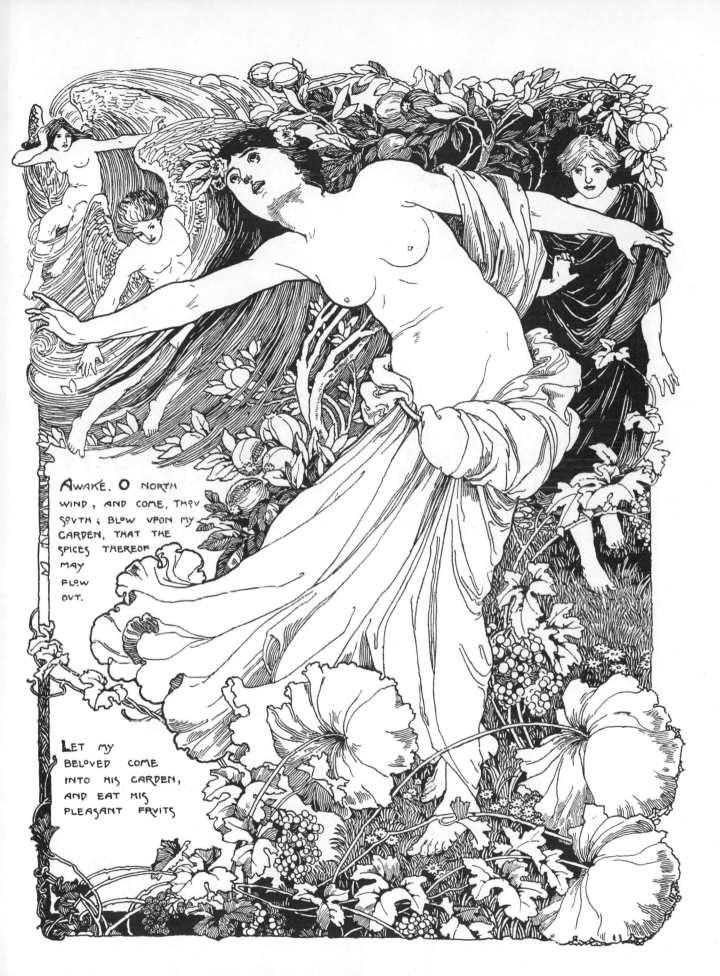

AWAKE. O NORTH
WIND, AND COME, THOU
SOUTH ; BLOW UPON MY
GARDEN, THAT THE
SPICES THEREOF
MAY
FLOW
OUT.

LET MY
BELOVED COME
INTO HIS GARDEN,
AND EAT HIS
PLEASANT FRUITS

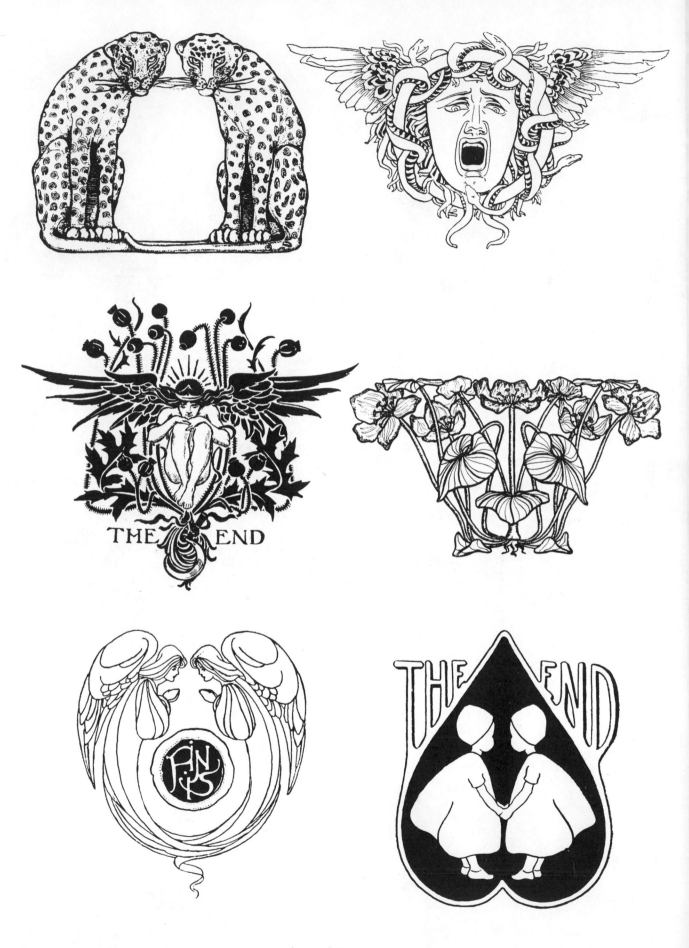